ÜBERSEE
EXPLORING VISUAL CULTURE

CONTENT

PAGE	3 – 9	LORETTA LUX
PAGE	10 – 17	GENEVIEVE GAUCKLER
PAGE	18 – 23	PATRICK LINDSAY
PAGE	24 – 65	KID'S STUFF? NOT EXACTLY.
PAGE	66 – 71	VIER5
PAGE	72 – 75	MONGREL ASSOCIATES
PAGE	76 – 81	BLESS
PAGE	82 – 89	KORATERS
PAGE	90 – 99	BENJAMIN GÜDEL
PAGE	100 – 111	PETER HORVATH
PAGE	112 – 123	SEB JARNOT
PAGE	124 – 131	NEASDEN CONTROL CENTRE
PAGE	132 – 137	NIKO STUMPO
PAGE	138 – 143	BASTIEN AUBRY
PAGE	144	INDEX

LORETTA LUX

PAGE No. TITEL

"My pictures of children are not portraits in the true meaning of the word. They are rather imaginary portraits. I always choose models that I can somehow identify with, that remind me of my own childhood. What interests me about children is the mixture of vulnerability and pride, genuineness and learned behaviour, self awareness and hidden knowledge. I am exploring the awakening of the self.

As a trained painter, I don't consider myself a photographer. My main influences and inspirations are great Italian painters like Pinturicchio and Bronzino, Spanish painters like Velasquez and Goya and the German romanticists. Some of my works refer to fairytales and myths, such as 'The Rose Garden', but they are never direct quotes."

Born 1969 in Dresden/Germany Loretta Lux studied painting and graphic design in Munich and London (winning a DAAD scholarship). Her work is part of public collections like the "Bayerische Staatsgemäldesammlung". She has been exhibited and published internationally and was recently commissioned by Wieden + Kennedy, Tokyo.

3	•	THE RED BALL # 1
4	•	HIDDEN ROOMS # 2
5	•	THE ROSE GARDEN
6	•	MARIA # 2
7	•	HECTOR # 1
8	•	DOROTHEA
9	•	ISABELLA

ALL PHOTOS © LORETTA LUX VG BILDKUNST 2001 ILLFOCHROME

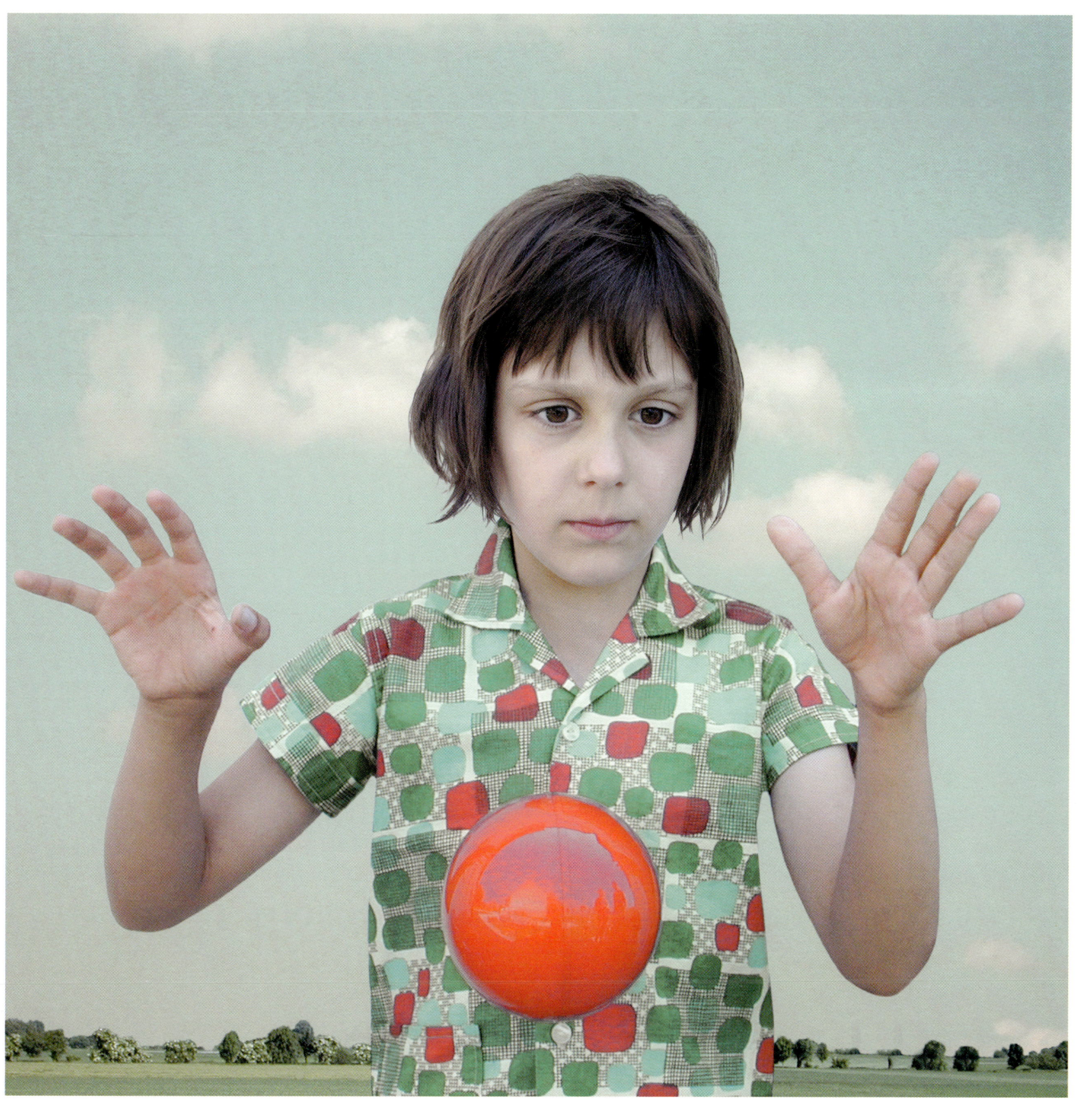

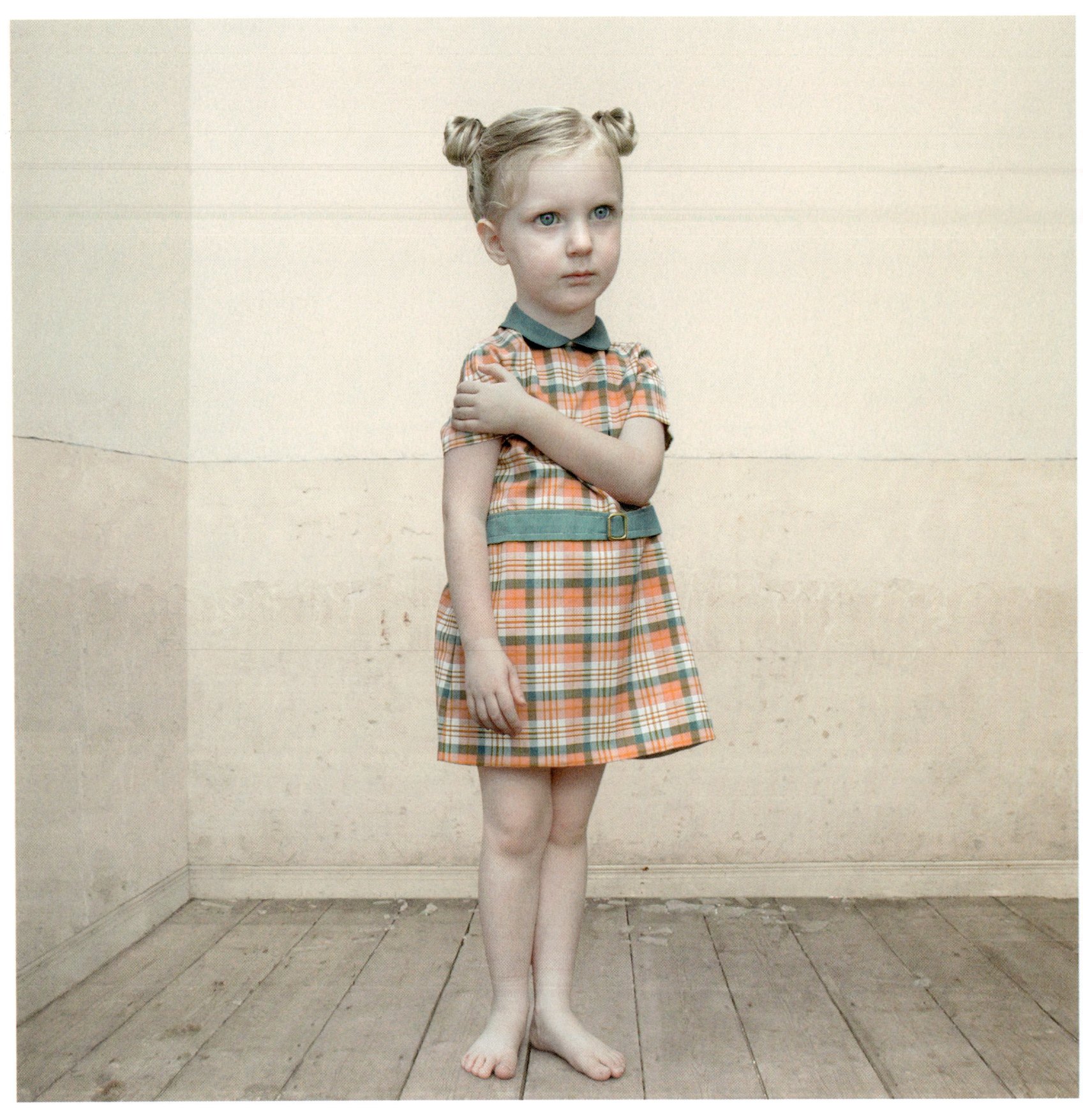

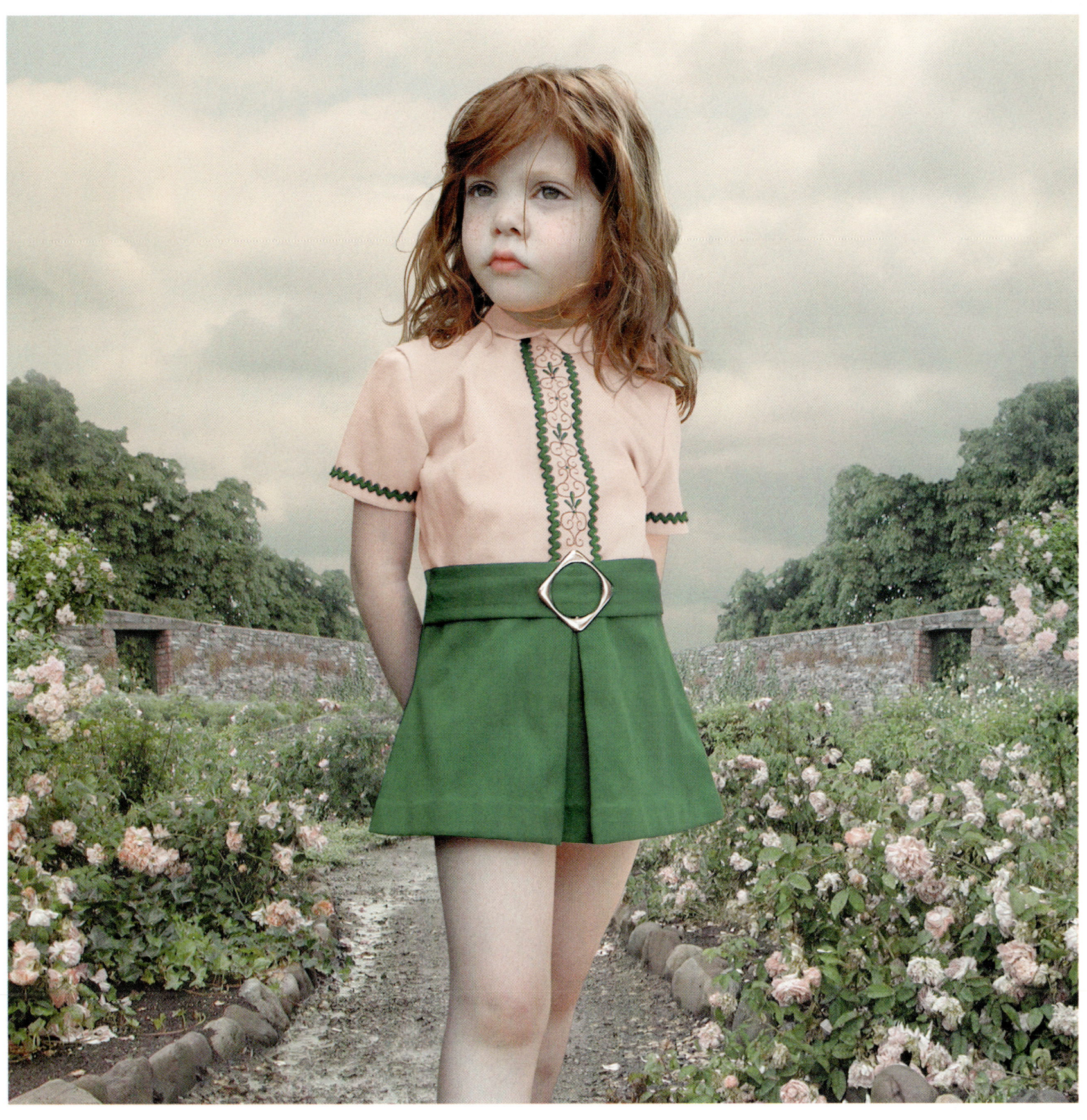

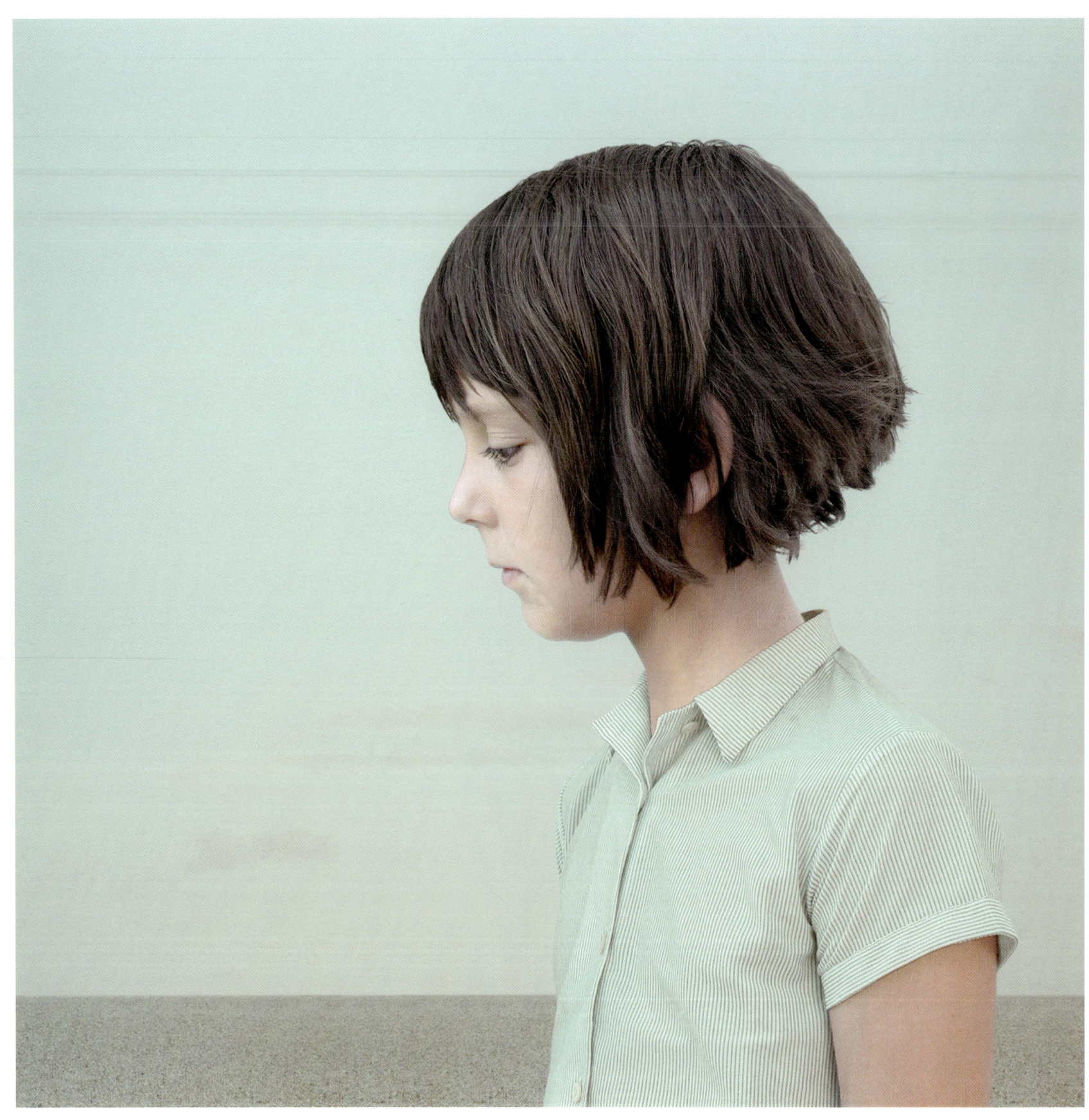

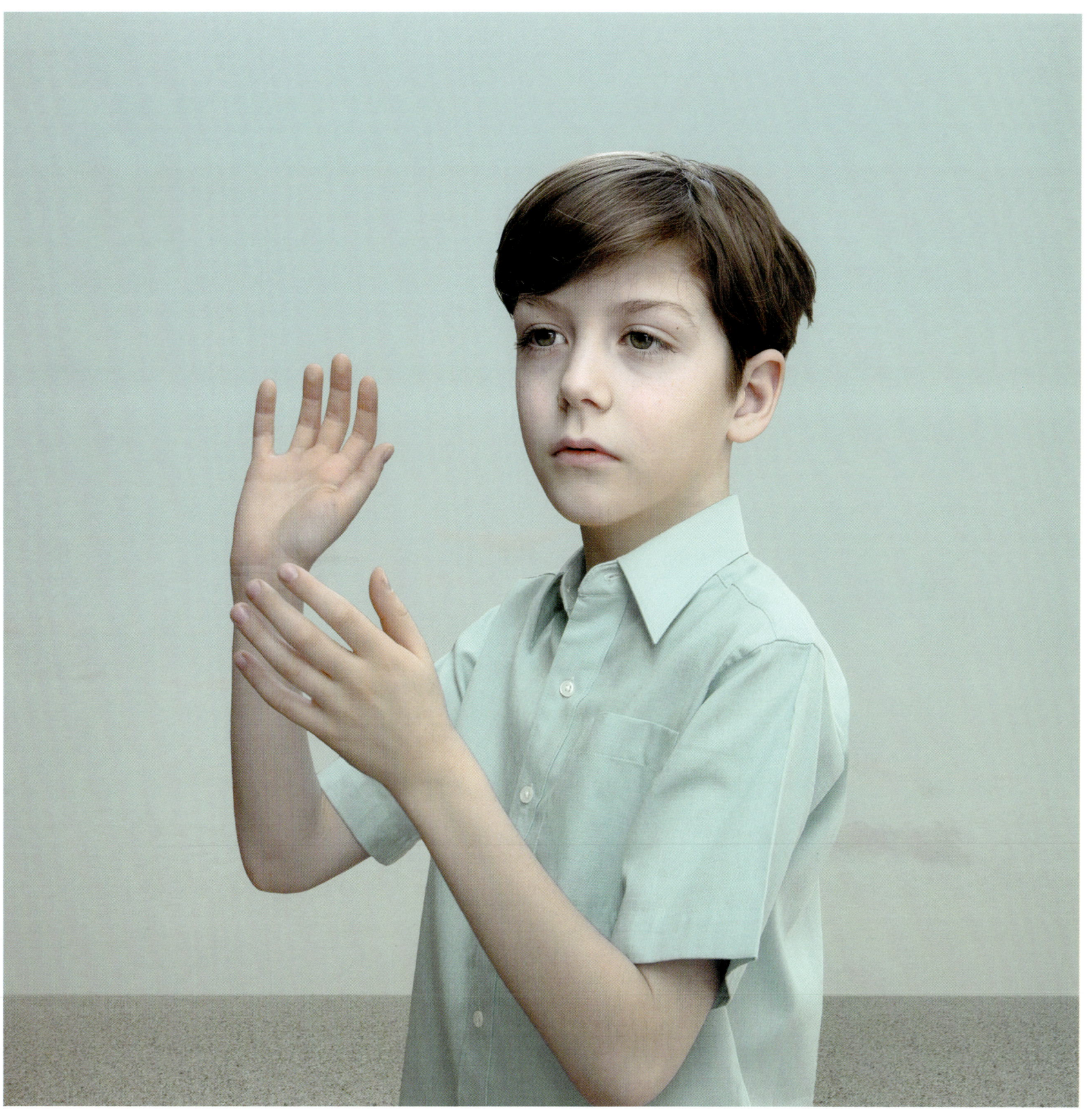

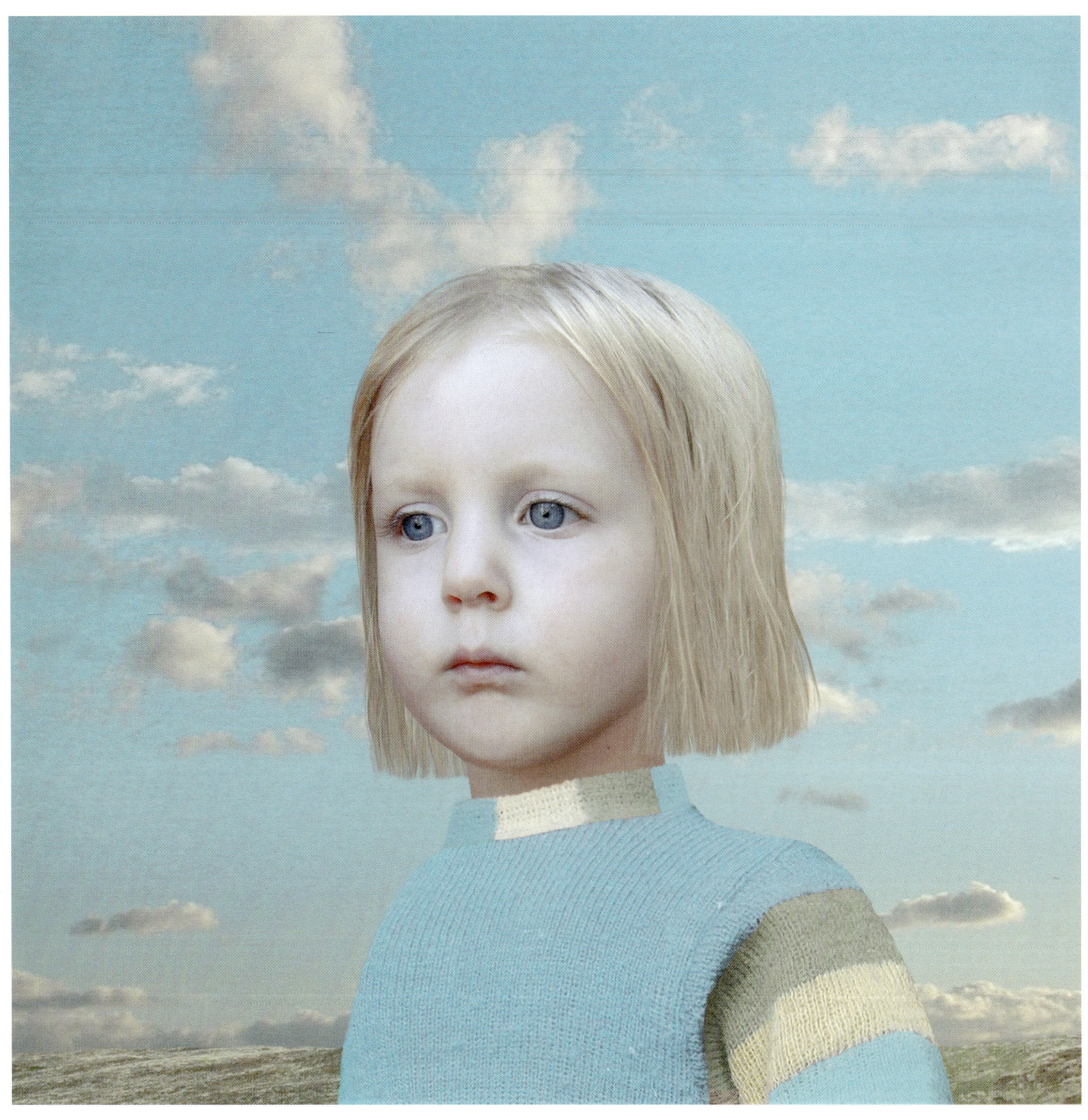

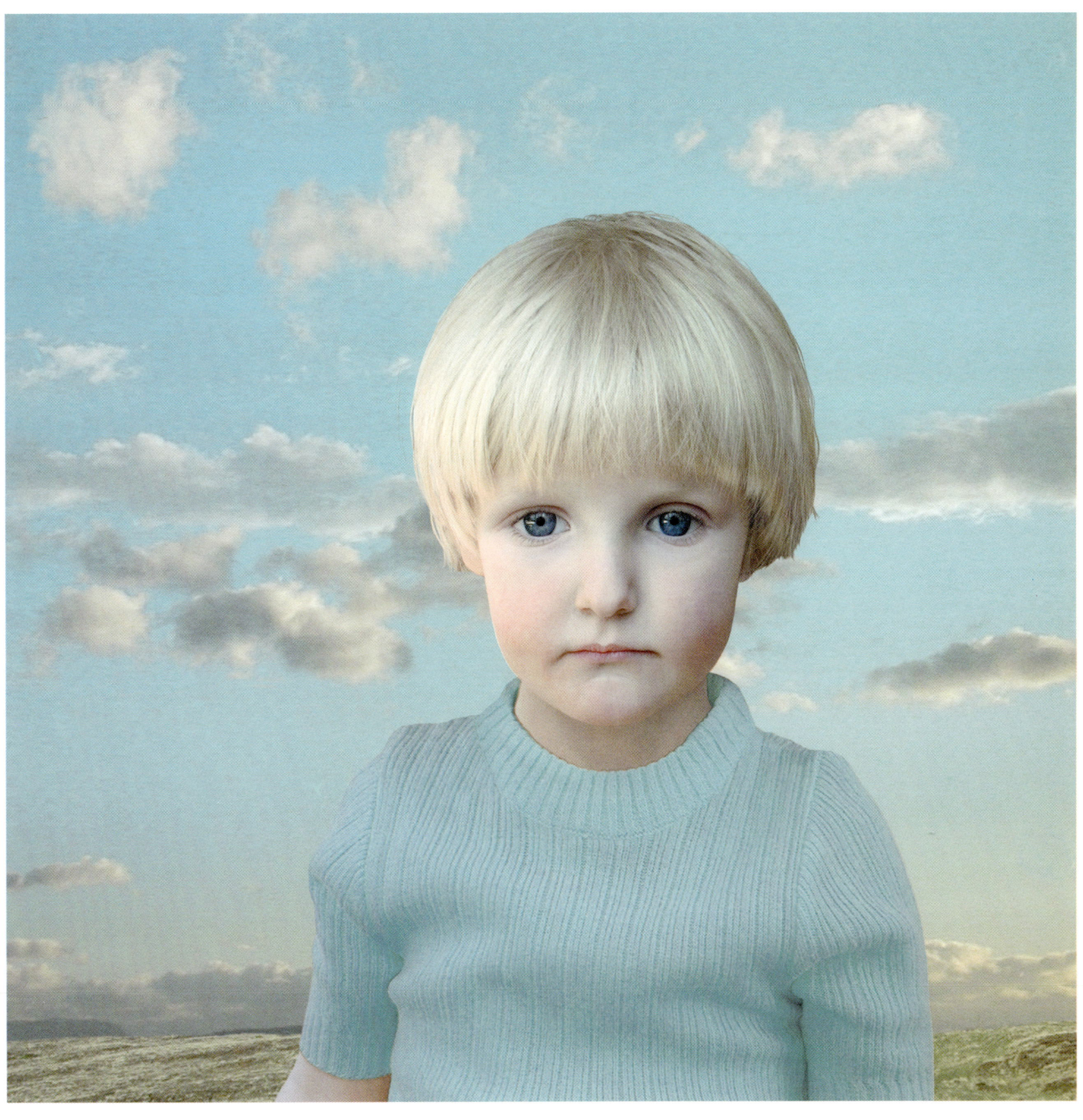

GENEVIEVE GAUCKLER

PAGE No. TITEL

French born Genevieve Gauckler can look back on broad experience in the field of graphic design, illustration and art direction. Starting with French record company F Communications (Laurent Garnier, St Germain, etc). she later worked with the directors Olivier Kuntzel and Florence Deygas on promos for Dimitri from Paris, Pierre Henry and Sparks, as well as on commercials (e.g. Yves Saint Laurent's Live Jazz), titles for French/German cultural TV-channel Arte and short movies like Tigi and Velvet 99.

Since 2001 Genevieve has been focussing on videos (e.g. Brigitte Fontaine's "Y'a des Zazous" video with Estelle Saint Bris), websites (Grumly), illustrations and graphic design.

She is also part of Pleix, a collective of French graphic designers, 3D artists and musicians. Right now Pleix mainly comprises underground work, but aims to branch out into music videos, titles, etc. Two of their videos have already featured at the OneDotZero festival in London. The latest one is "Itsu", a great promo for Plaid (Warp Records).

10	•	GOPIL
11	1	STUFFED GUYS
	2	STUFFED GUYS
	3	SIPHER
	4	STUFFED GUYS
	5	STUFFED GUYS
	6	MASCAP
12	•	MANDALA ONE
13	•	MANDALA TWO
14	•	MANDALA FOUR
15	•	MANDALA FIVE
16	•	SOME CHARACTERS FOR A COMIC BOOK PROJECT
17	•	GG RULES

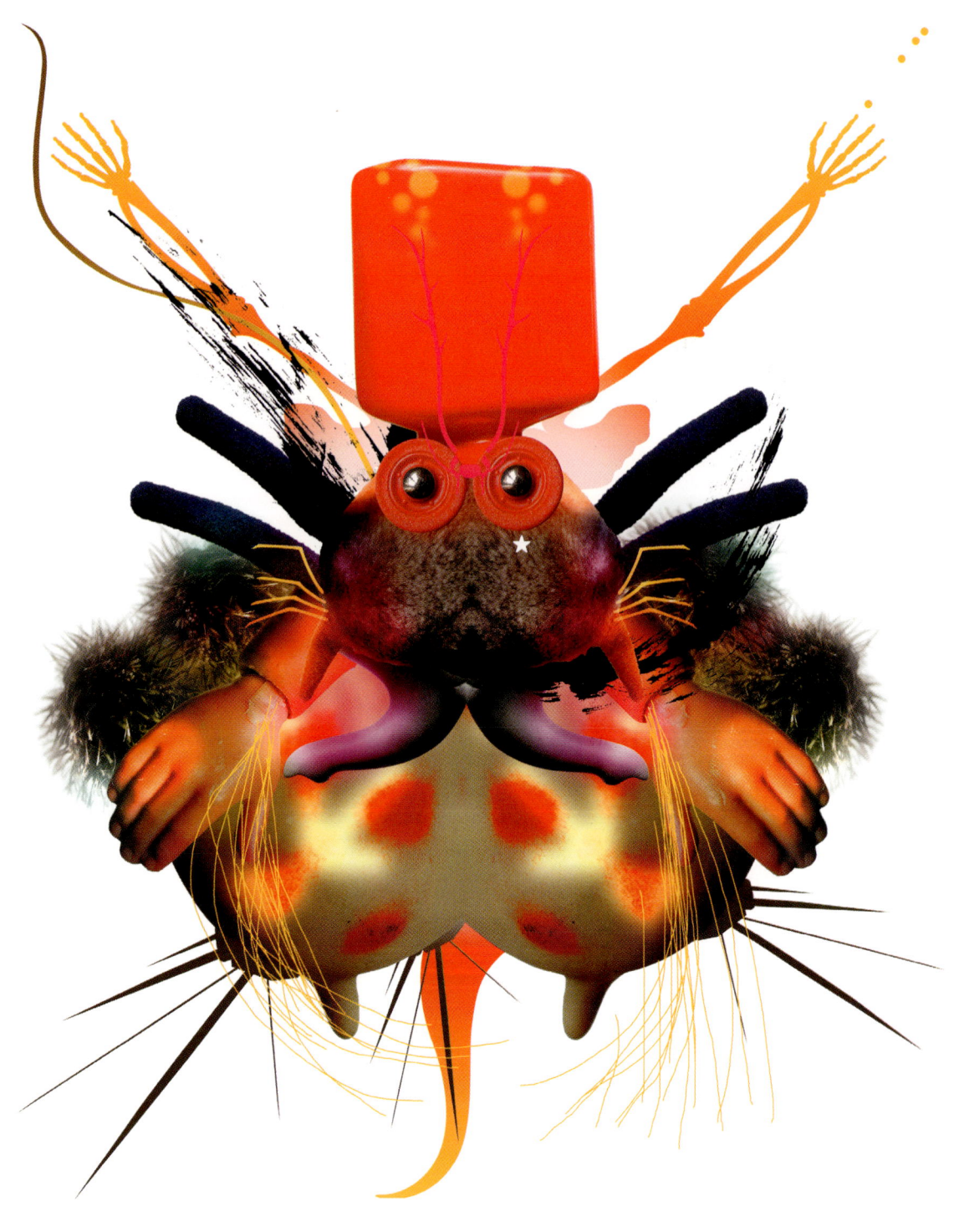

Ü / 10

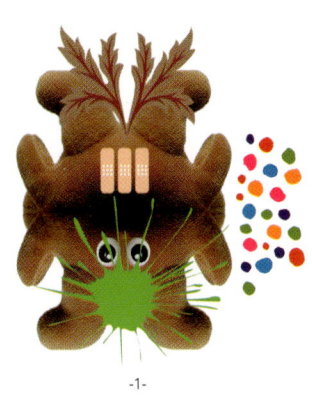
-1-

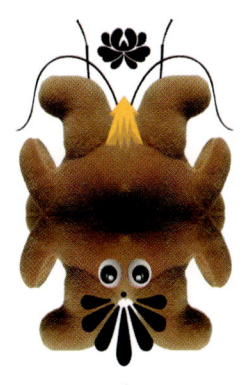
-2-

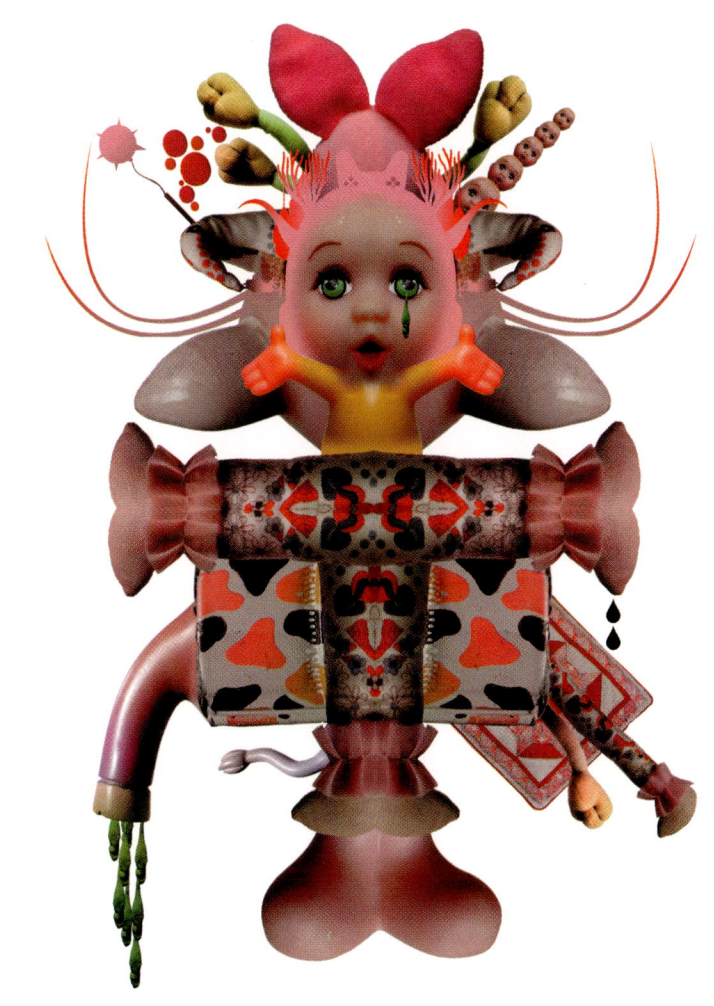
-3-

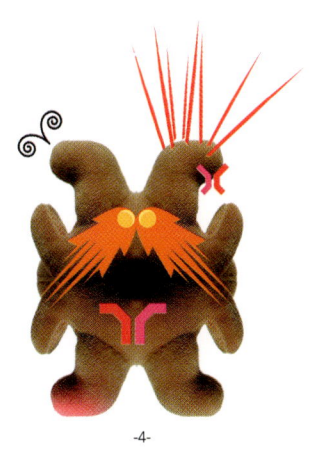
-4-

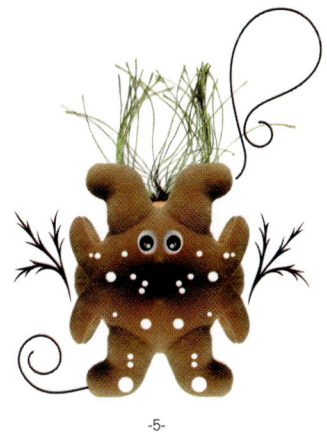
-5-

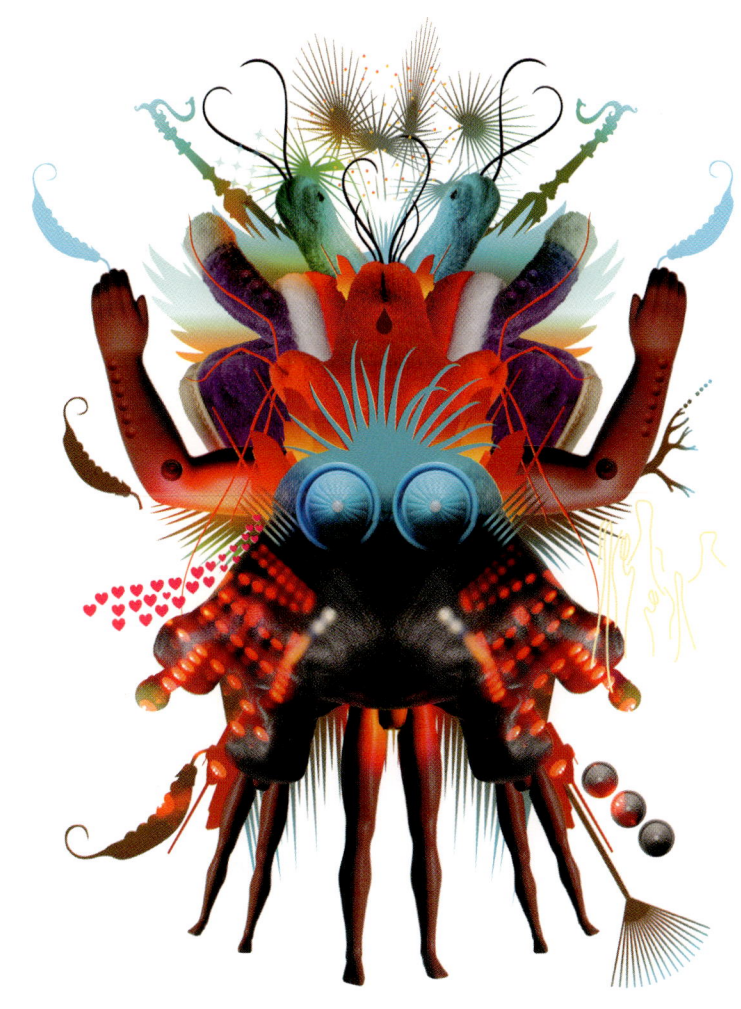
-6-

Ü / 11

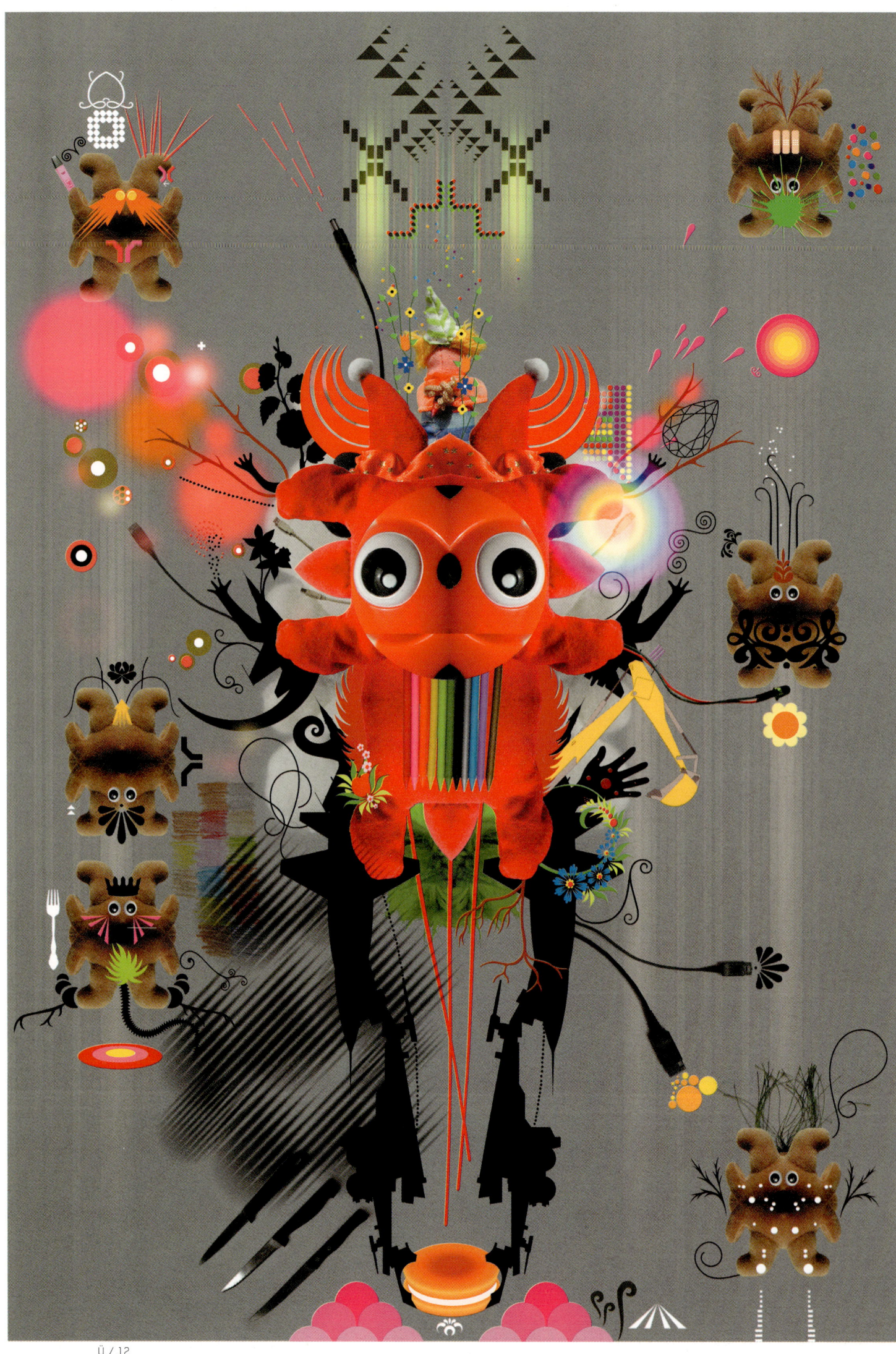

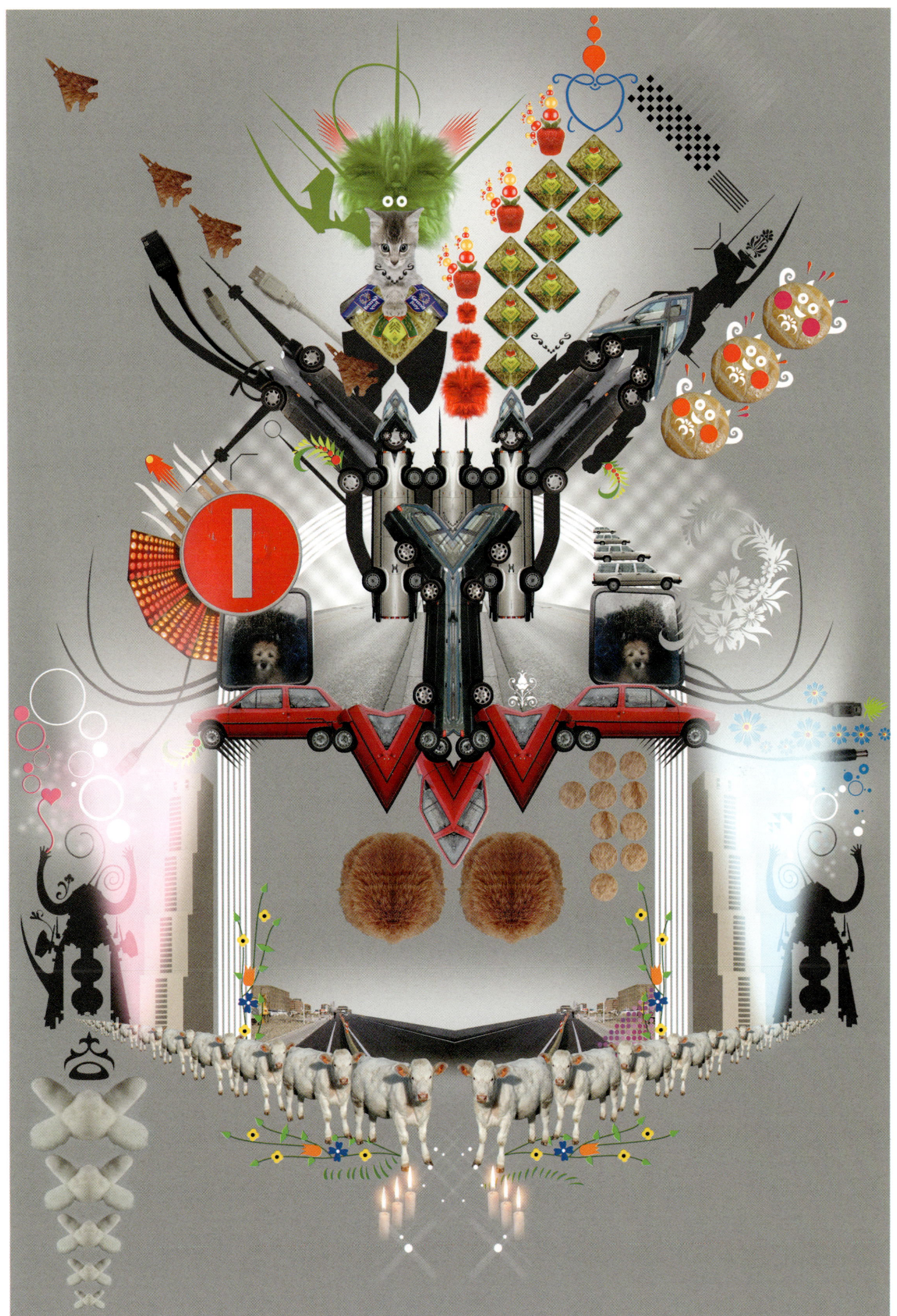

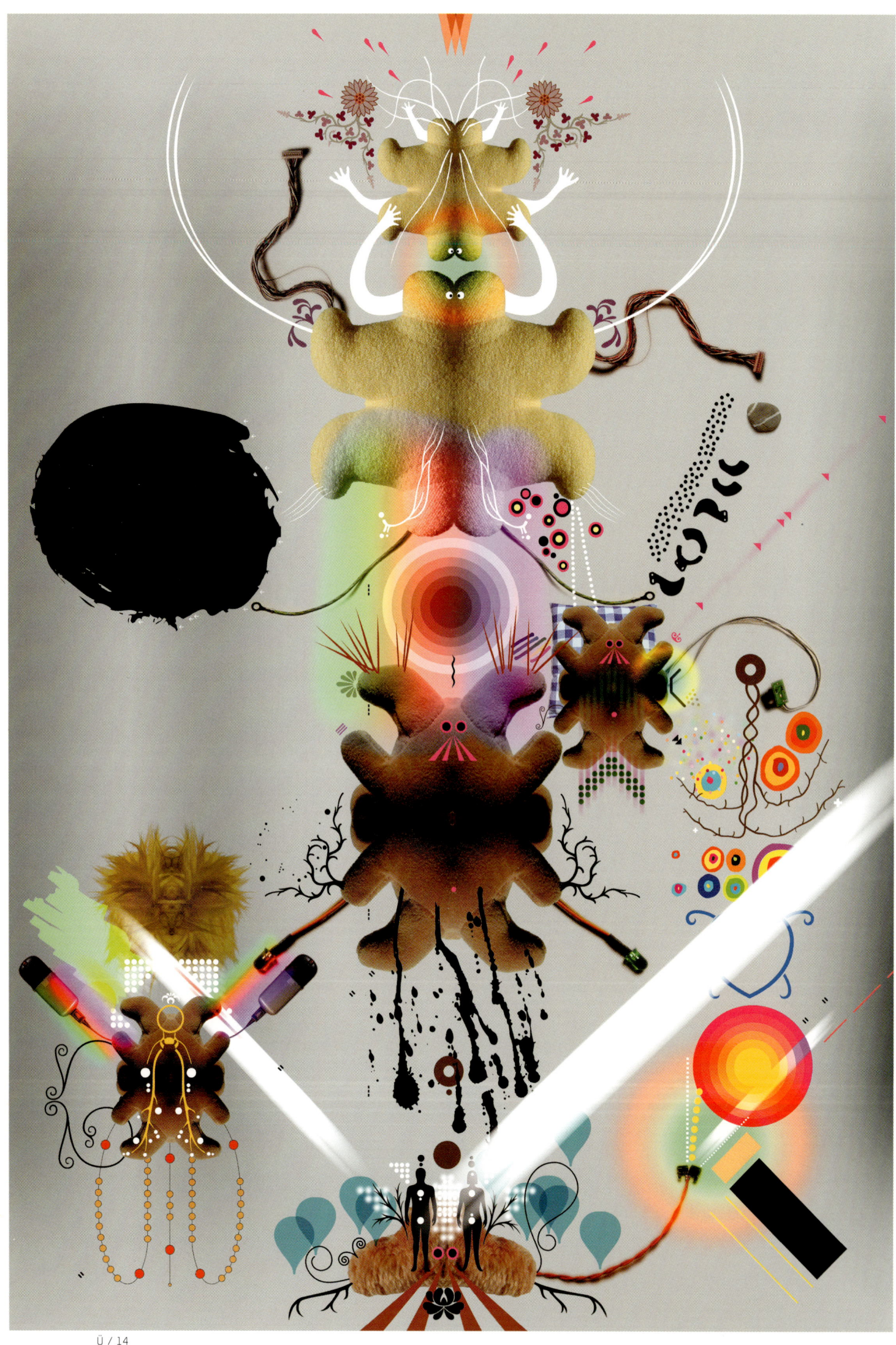

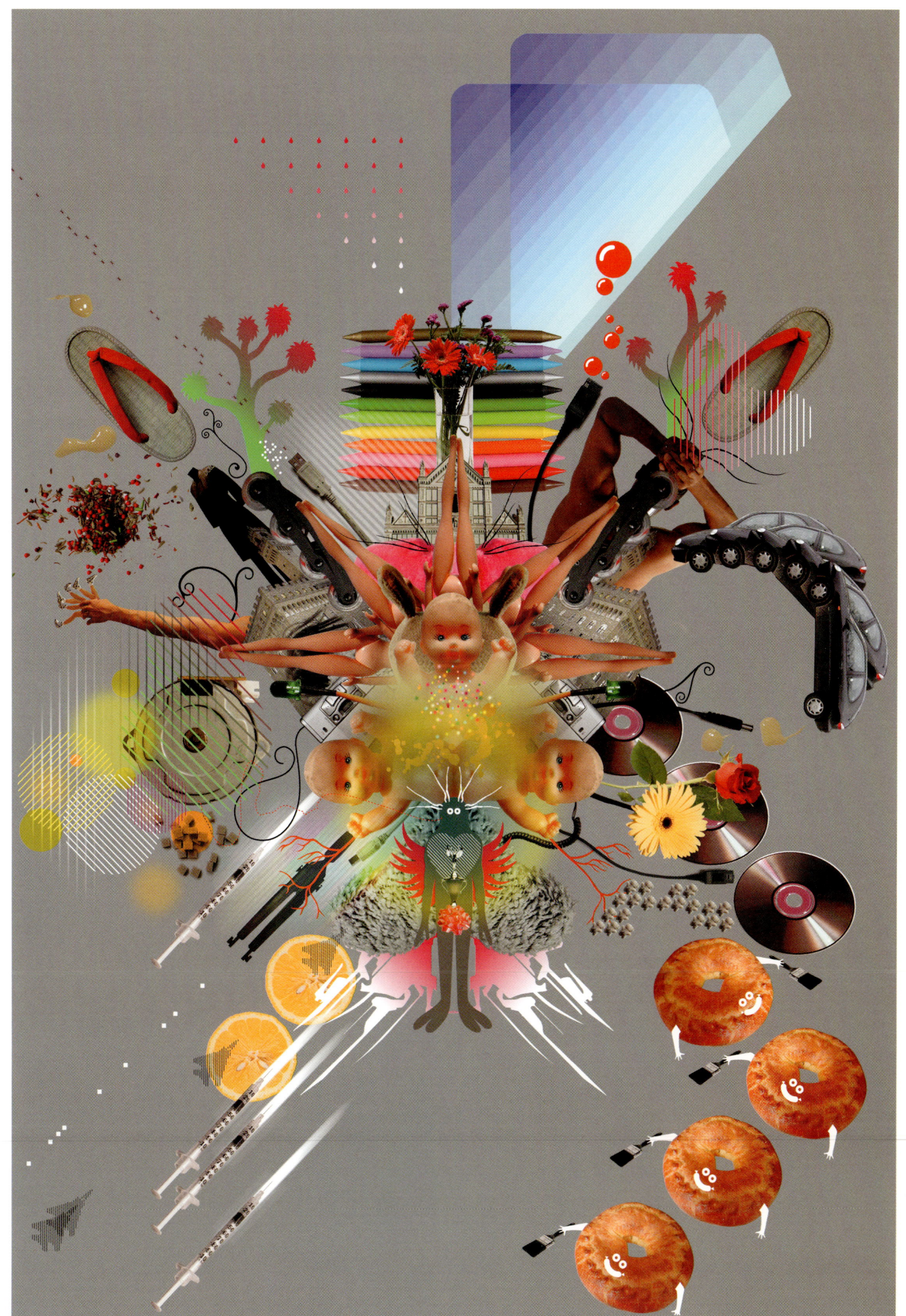

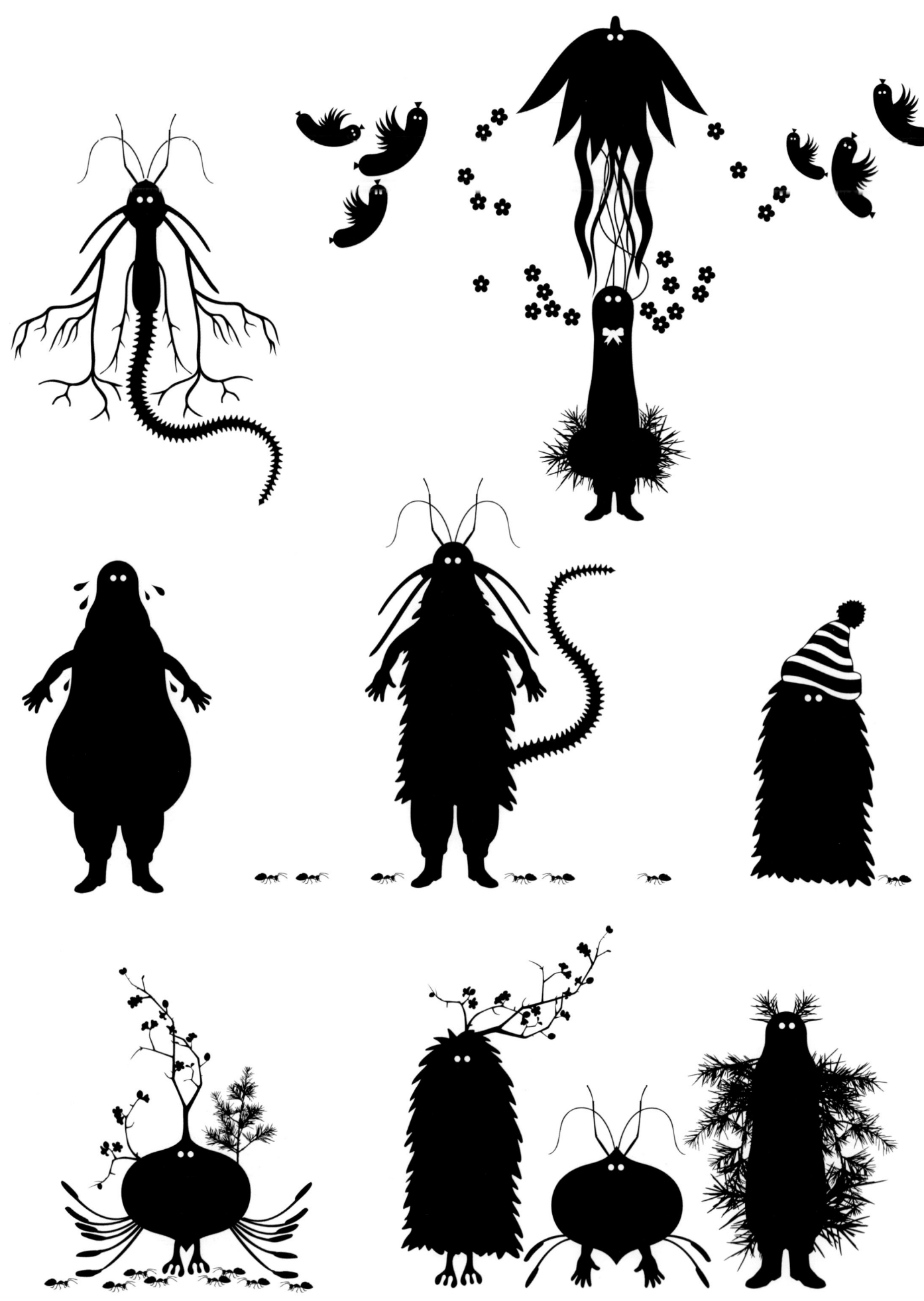

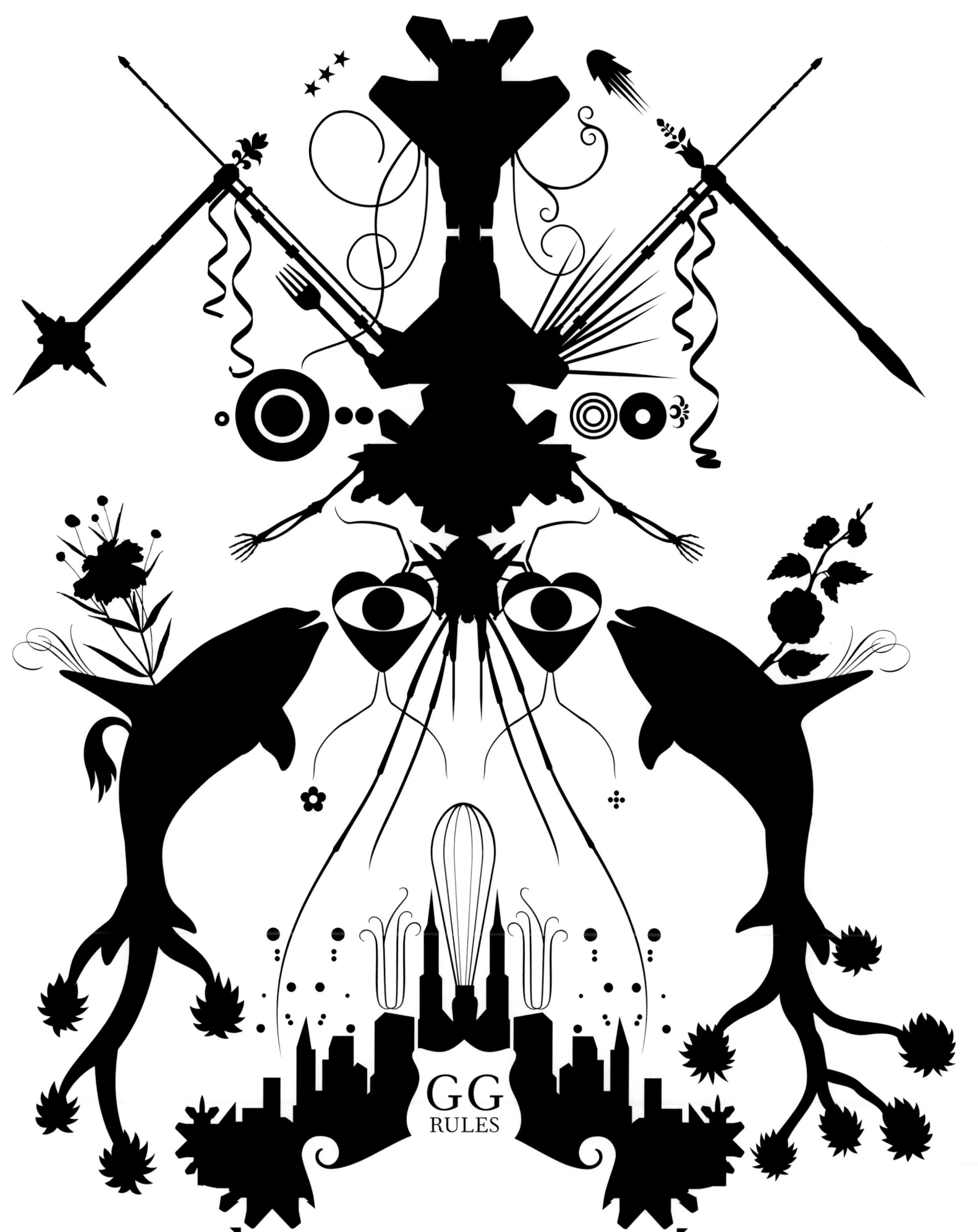

PATRICK LINDSAY

PAGE No. TITEL

Patrick Lindsays work is all about play. Much of the now 30-year-old's inspiration stems from his childhood days and the toys he used back then. His designs are colourful, inspirational and meant to be played with and developed further by the recipient.

Even though he always had a strong interest in typography he decided to study illustration at the Ecole Nationale Superieure des Arts Decoratifs and then used his skills as an illustrator to design playful fonts outside the grid.

His first assignment was a complete font based on Lego bricks for a catalogue about young designers by the "Office de la Culture de Marseille", a style he worked his own professional and personal 3D website environments.

Patrick is based in Marseille where he acts as a freelancer for clients such as Liberation and Le Monde interactif.

18	•	LE MONDE INTERACTIF
19	1	LE MONDE INTERACTIF
	2	MARSEILLE L'HEBDO
20	•	LE PAVÉ
21	•	LE MONDE INTERACTIF
22	1	NÎMES ESCRIME
	3	LE MONDE INTERACTIF
23	•	MARSEILLE CENTRE

-1-

-2-

va chercher

Ü / 22

KIDS' STUFF? NOT EXACTLY.

PAGE	NO.	CREATOR	TITEL

A new breed of puppets has made it into the limelight. Out of the nursery and straight into design offices, artist studios, boutiques, galleries, magazines, radio and TV programmes and onto sofas and collectors' shelves.

The puppets' are called Sozi, Jest or Schweinehund, they form the first ever hiphop toygroup „Puppetmastaz" and seem to spearhead a micro-movement away from the current slick digital game scapes to a cosy, warm, intimate, haptic experience.

But after all (and just like their keepers) the puppets shown on the following pages are not into romantic cocooning – sorry Faith Popcorn – and not necessarily suitable for toddlers.

Not exactly politically correct they are obviously sexual beings, aggressive, even mis-shaped, with a whole bucket full of problems, sometimes dead, sad or lonely. And, at the same time, it is this which makes them beautiful and human. Puppets for grown ups, puppets with attitude. And after all, Toys'R'Ours again.

PAGE	NO.	CREATOR	TITEL
25	•	DEHARA	MONTBRANO (photo by Daisaku Ito)
26	1	RINZEN	GREENOWL
	2	RINZEN	GREENFISH
27	•	RINZEN	DEADCAT
28	•	RINZEN	SKELETONCATBIRD
29	•	RINZEN	SKELETONSOZI
30	•	H 55 AND BRENDA NG	MONKEY (Photos by Ivan Lo)
31	•	H 55 AND BRENDA NG	LAMB (Photos by Ivan Lo)
32	1	JEST	LONG ARM
	2	JEST	LEATHER
33	•	JEST	WOOL
34	1	JEST	DESERT STORM
	2	JEST	PEANIE BLUE STANDING
35	1	JEST	CLOWN
	2	JEST	TURD
36	•	JEST	PEENIE MAN
37	1	JEST	CLOWN FLYING
	2	JEST	TWO SHARKS ON A WALL
38	1	BORIS HOPPEK	PILLE PUPPE
	2	BORIS HOPPEK	PILLE BABY
39	•	BORIS HOPPEK	WILDER
40	•	BORIS HOPPEK	LEO
41	•	BORIS HOPPEK	SCHWEINEHUND
42	•	NON CONZEPTUAL	UNTITLED
43	•	NON CONZEPTUAL	UNTITLED
44	1	KEIKO MIYATA	THE SKY (photo by Keiko Miyata 2001)
	2	KEIKO MIYATA	BLACK BOX (photo by Etsuko Miyasaka 2002)
45	•	KEIKO MIYATA	HACHI-USA (BEERABBIT) (photo by Keiko Miyata 1995)
46	•	KEIKO MIYATA	RED BOX (photo by Etsuko Miyasaka 2002)
47	•	KEIKO MIYATA	CHIROL (photo by Keiko Miyata 1999)
48	•	LITTLEMISSLUZIFER	KELLY & LINDSAY (photo by Martin Eberle)
49	1	LITTLEMISSLUZIFER	SID & NANCY
	2	LITTLEMISSLUZIFER	KALLE & AALIYAH
	3	LITTLEMISSLUZIFER	V.R. LINDA, PAUL, LUZY, AMBER, BUNNY, KIMMY
	4	LITTLEMISSLUZIFER	DEAD BUNNY & MISSY
50-51	•	PUPPETMASTAZ	UNTITLED
52	1	PUPPETMASTAZ	SNUGGLES
53	•	PUPPETMASTAZ	FROGGA
54	•	PUPPETMASTAZ	FROGGA
55	1	PUPPETMASTAZ	RICARDO PROSETTI
	2	PUPPETMASTAZ	MR. ALOKE
56	1	PUPPETMASTAZ	ALFONSO TURBID THE TOAD
	2	PUPPETMASTAZ	HUEY REINHARDT
	3	PUPPETMASTAZ	E-WIZZ
	4	PUPPETMASTAZ	WIZARD
	5	PUPPETMASTAZ	THE BUDDAH
	6	PUPPETMASTAZ	CROUCHOLINA
	7	PUPPETMASTAZ	PIT
	8	PUPPETMASTAZ	THE BLOKE
	9	PUPPETMASTAZ	RICARDO PROSETTI
57	1	PUPPETMASTAZ	FLIX
	2	PUPPETMASTAZ	CROUCHO THE WOUCHO
	3	PUPPETMASTAZ	UNKNOWN
	4	PUPPETMASTAZ	SNUGGLES
	5	PUPPETMASTAZ	HAMMER
	6	PUPPETMASTAZ	WIZARD (YOUNG)
	7	PUPPETMASTAZ	RICHE LES LIEUX
	8	PUPPETMASTAZ	MR. ALOKE
	9	PUPPETMASTAZ	LISA
58	1	PLASTILAND	KLEMENTIENE
	2	PLASTILAND	RIDING DI-E
59	•	PLASTILAND	ACHIM GURKTRUM
60	•	DEHARA	FRIENDSHIP (photo by Yukinori Dehara)
61	•	DEHARA	FLYING SATOSHI (photo by Yukinori Dehara)
62	1	DEHARA	FRIENDSHIP (photo by Yukinori Dehara)
	2	DEHARA	HOW MUCH? (photo by Yukinori Dehara)
63	•	DEHARA	SAM (photo by Daisaku Ito)
64	•	DEHARA	MISS ROCK (photo by Yukinori Dehara)
65	1	DEHARA	SADNESS (photo by Yukinori Dehara)
	2	DEHARA	SADNESS (photo by Yukinori Dehara)
	3	DEHARA	SHOOTING (photo by Yukinori Dehara)
	4	DEHARA	CHOPPER (photo by Yukinori Dehara)

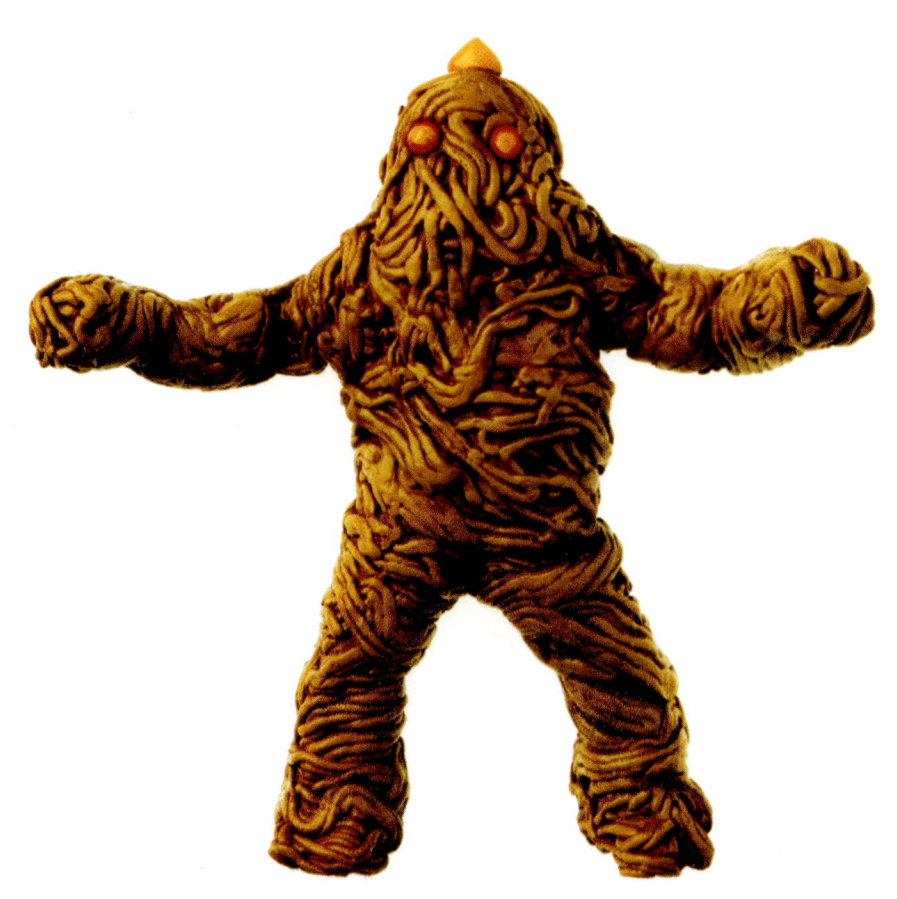

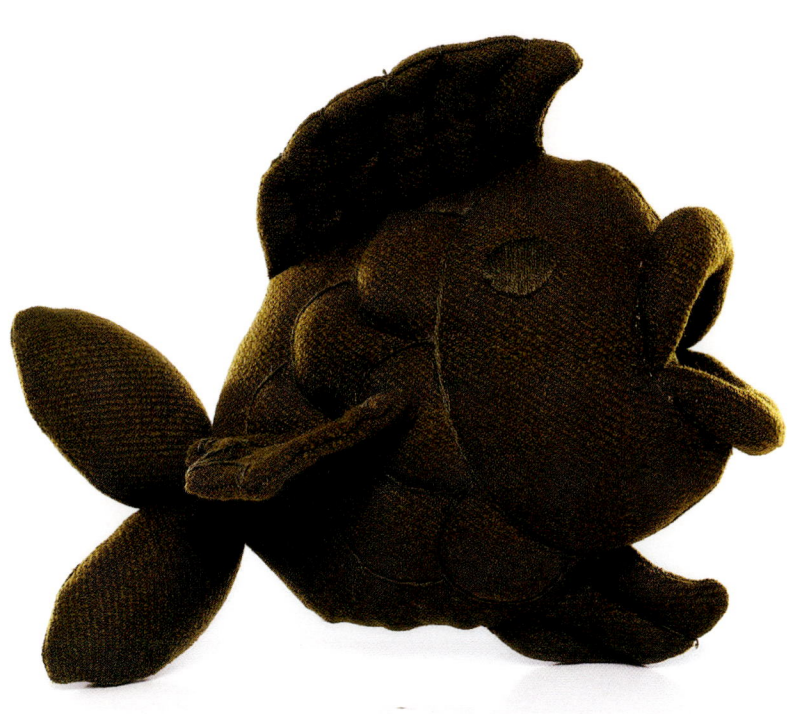

-1-

-2-

Ü / 26

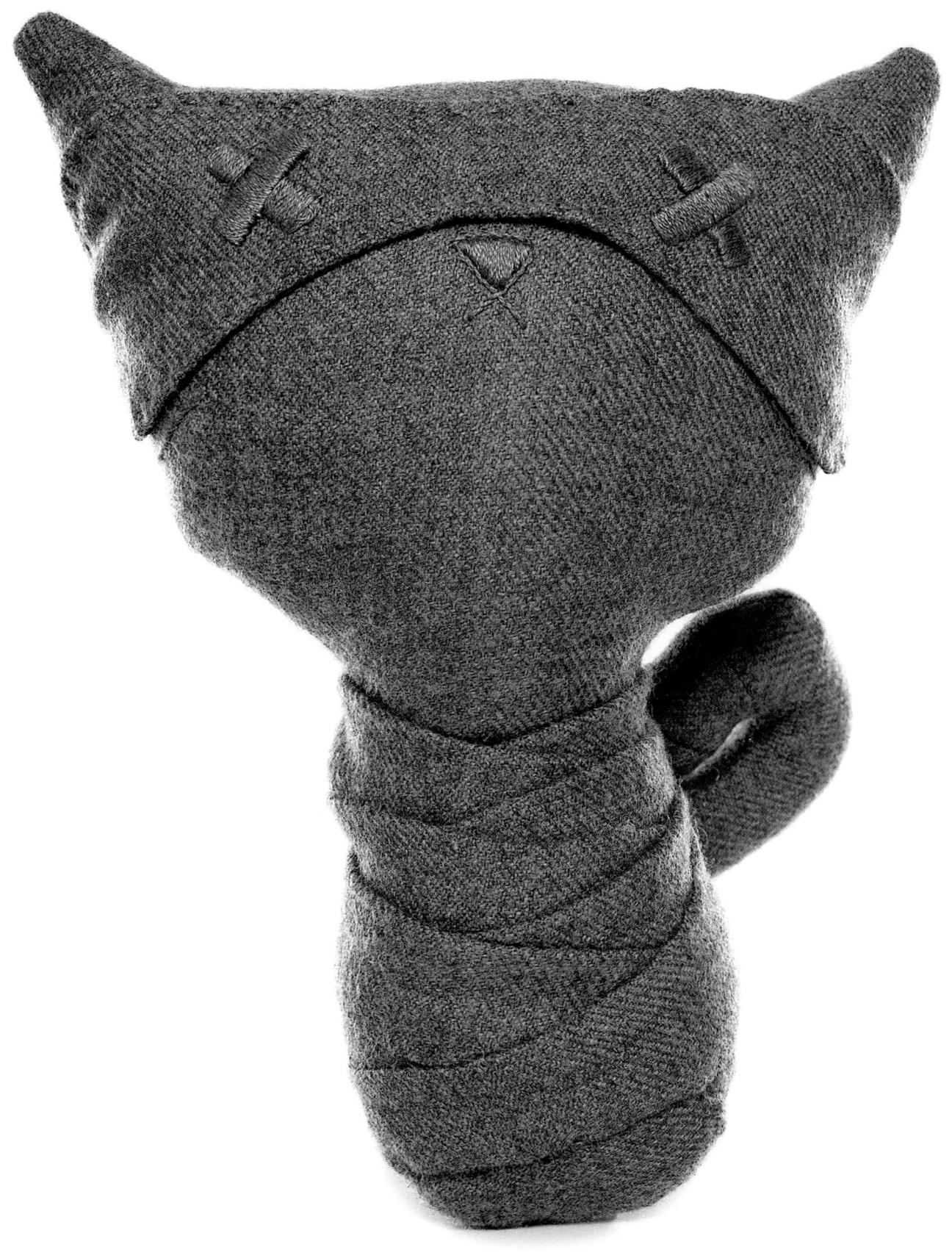

Ü / 27

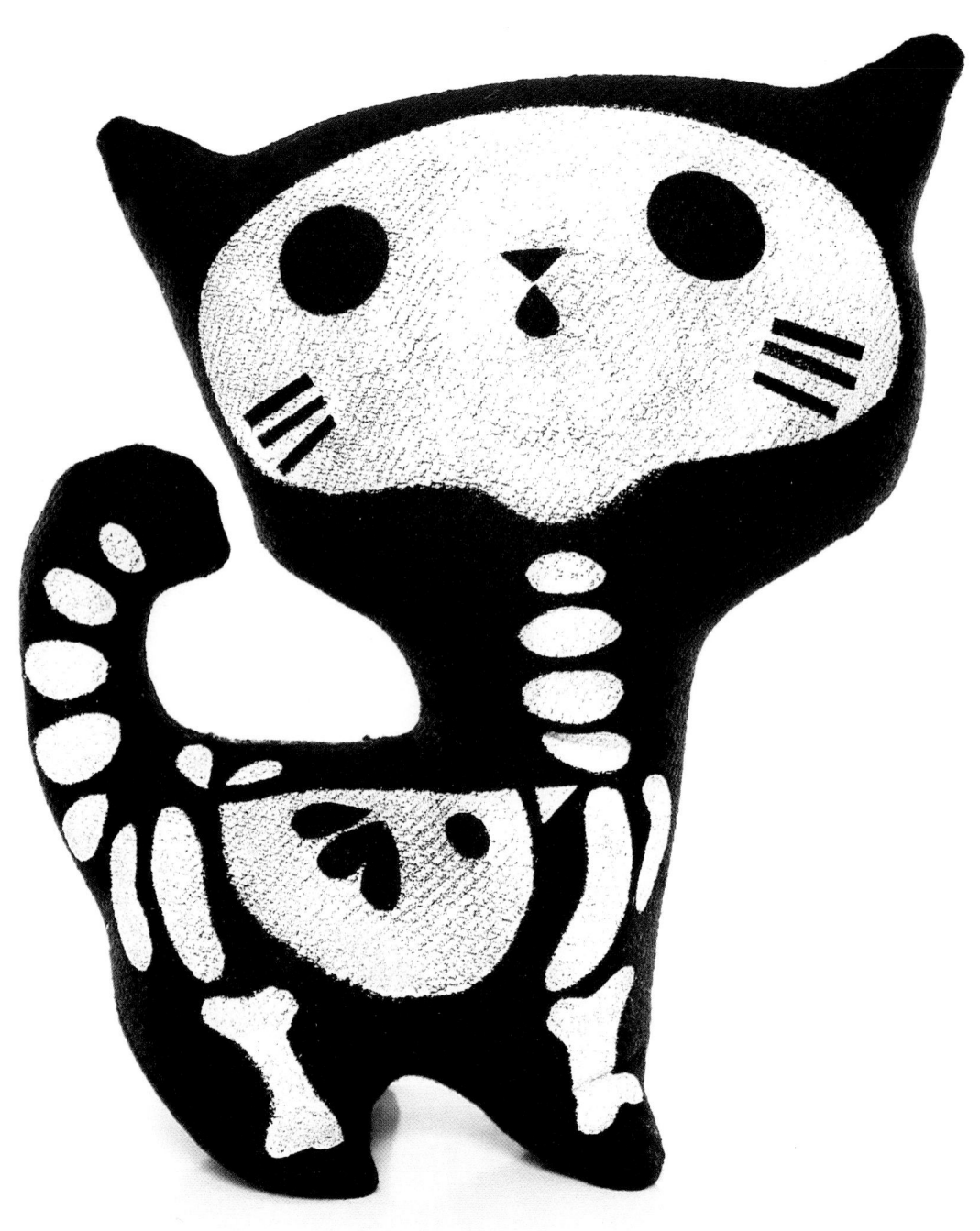

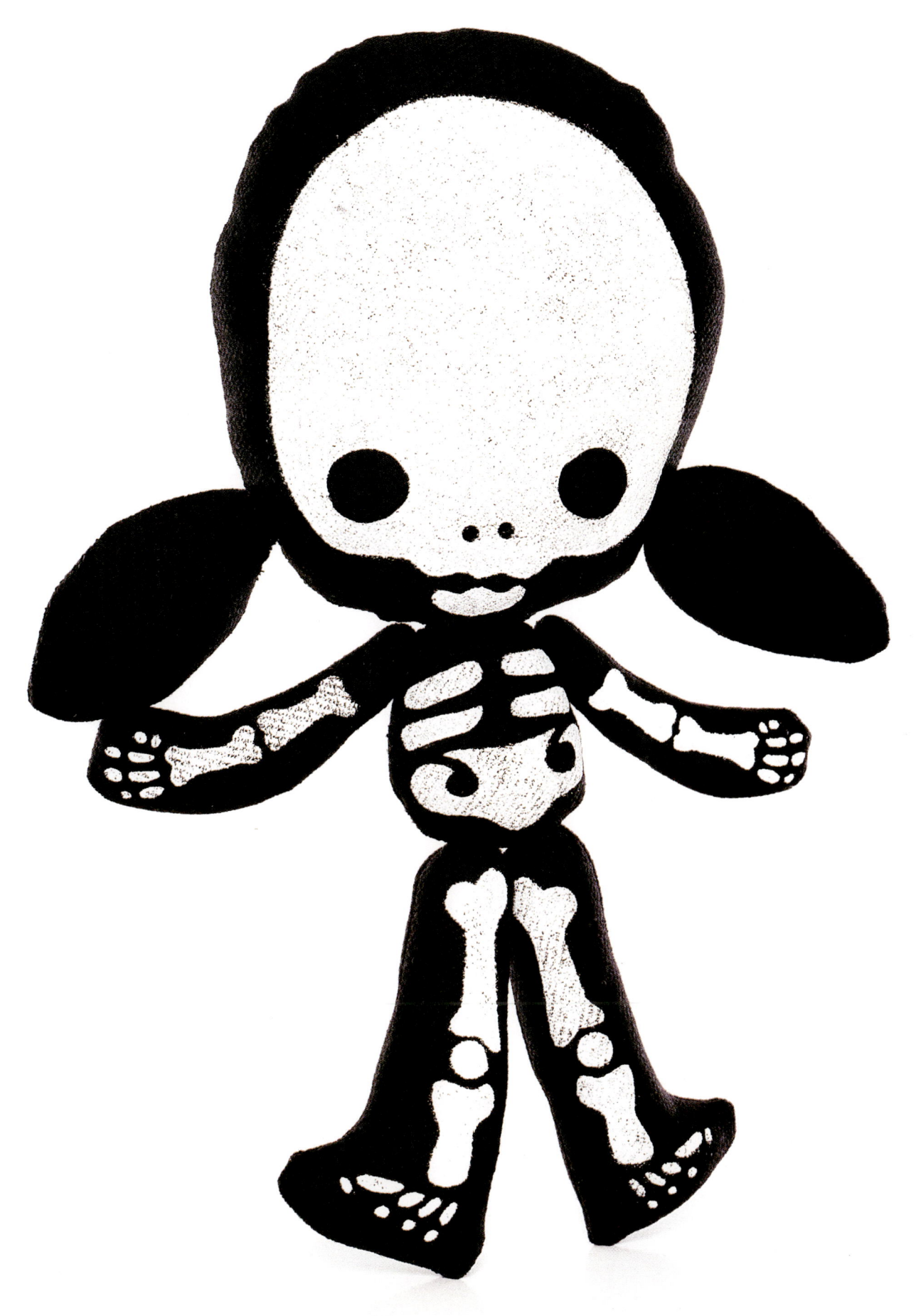

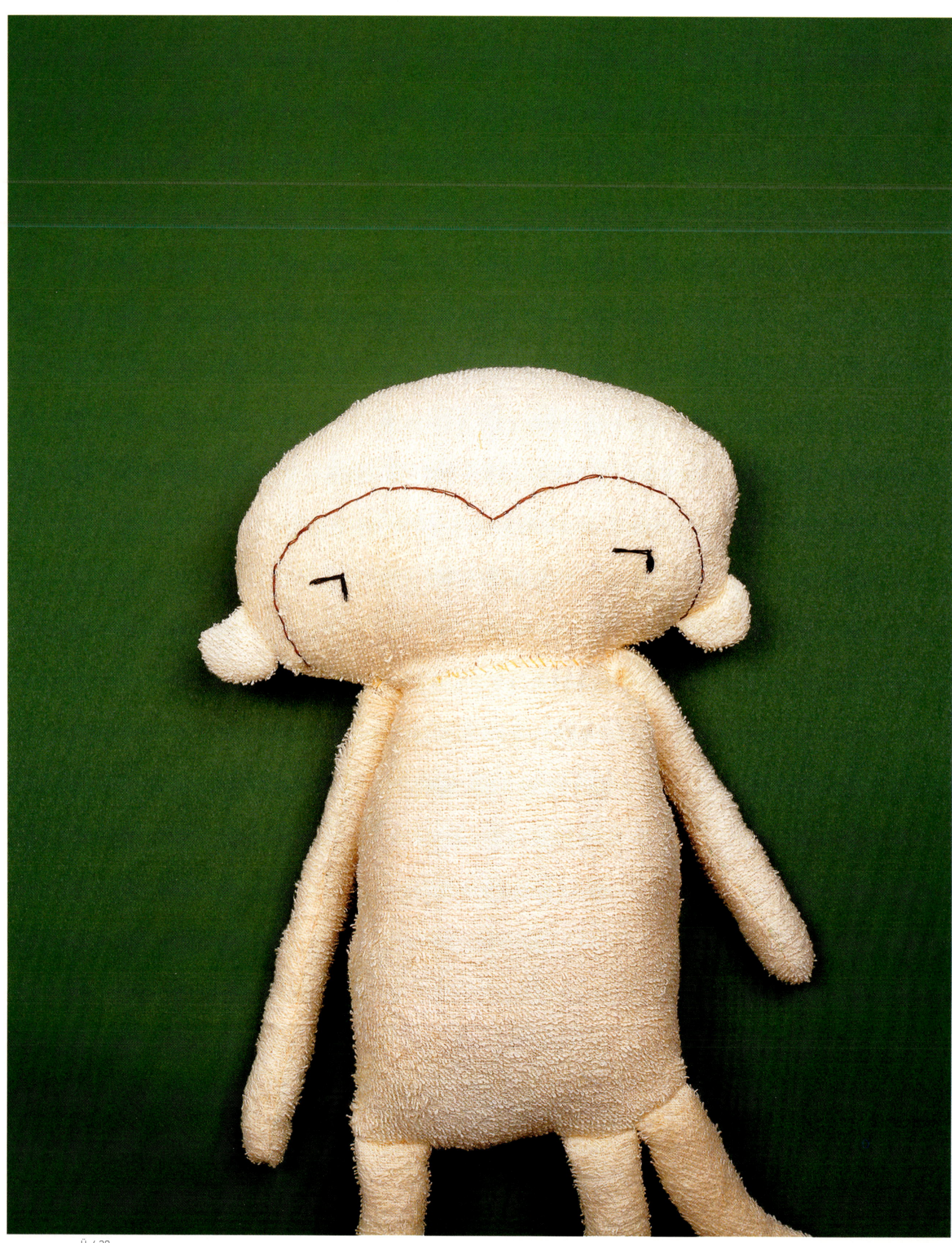

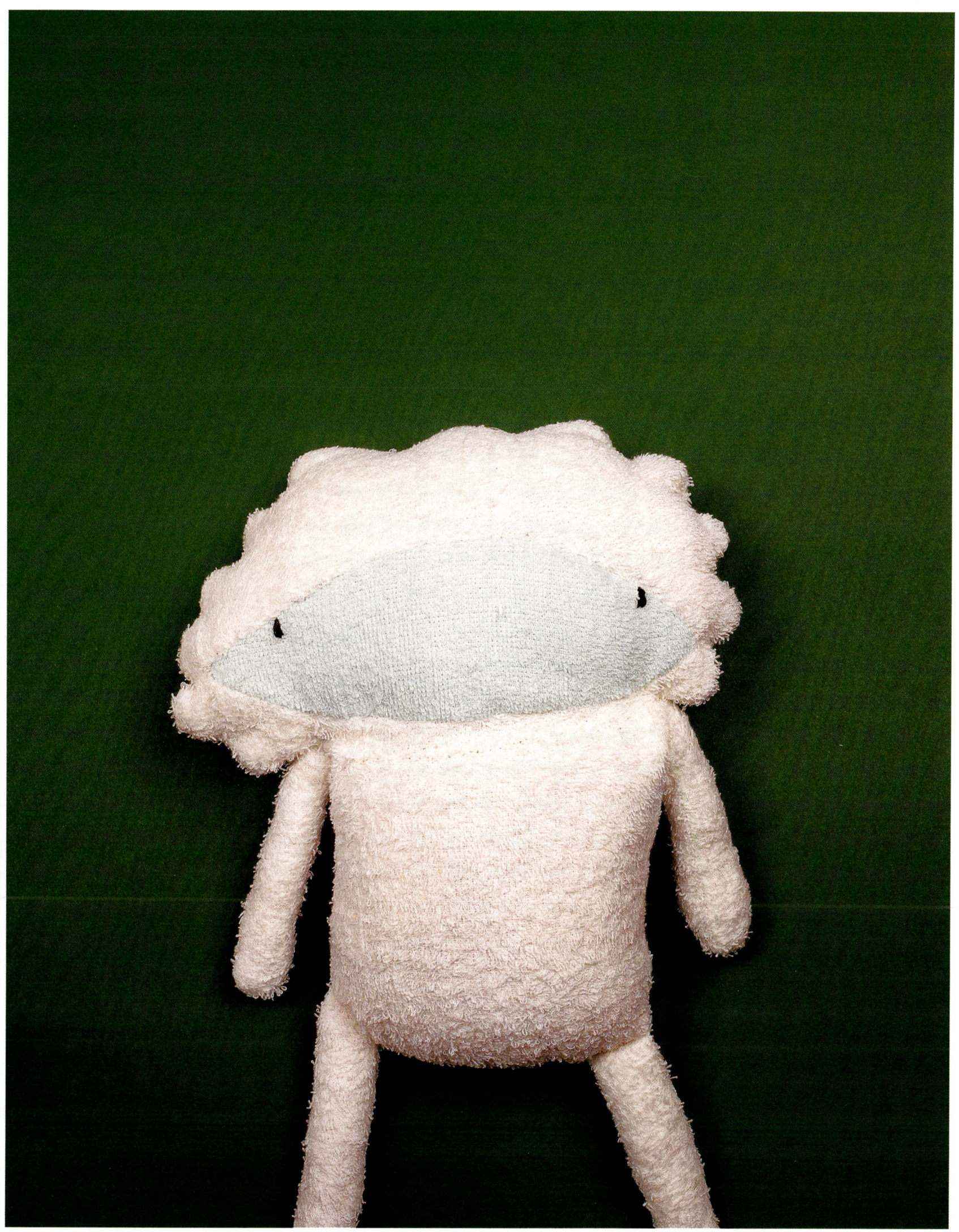

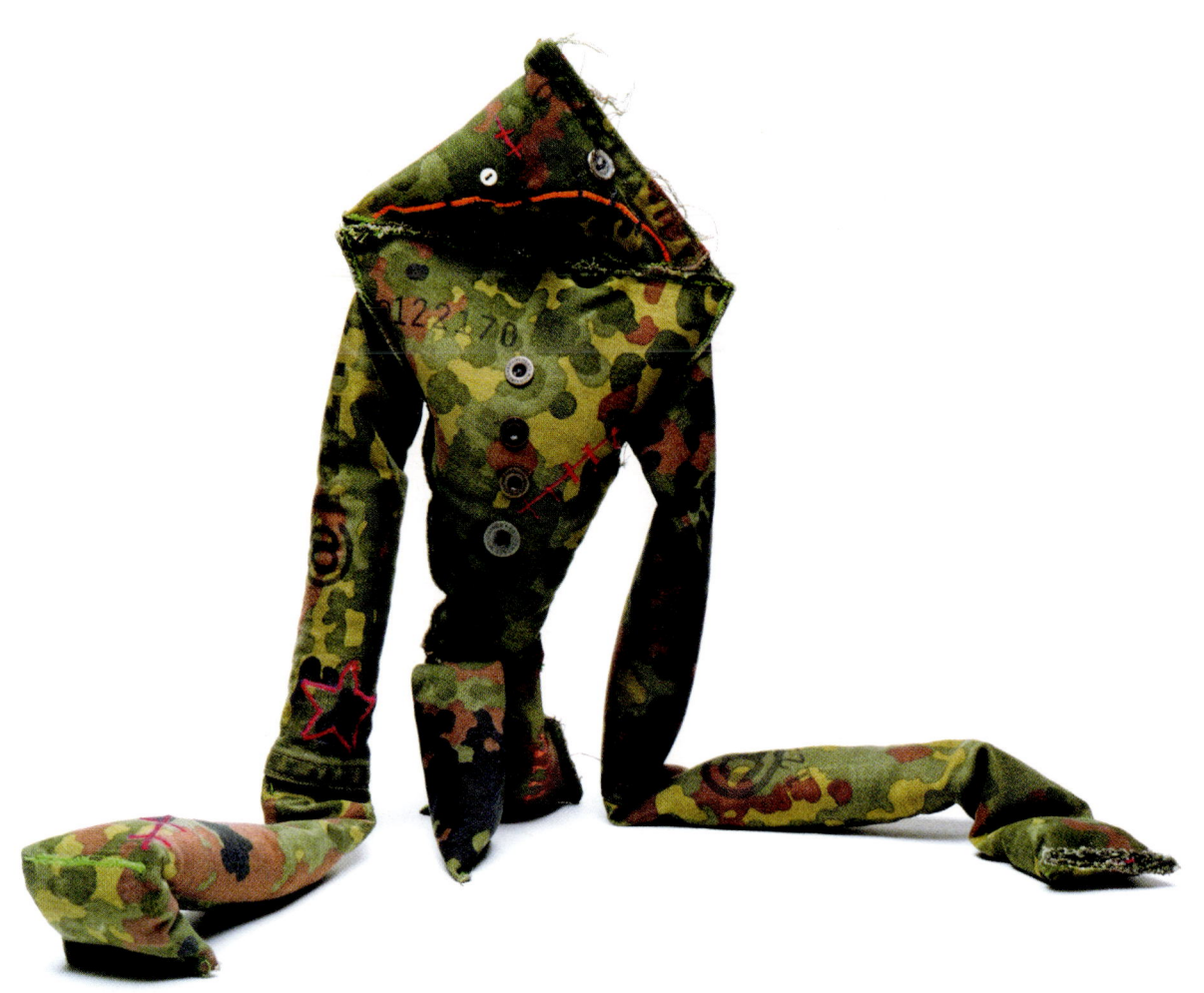

-1-

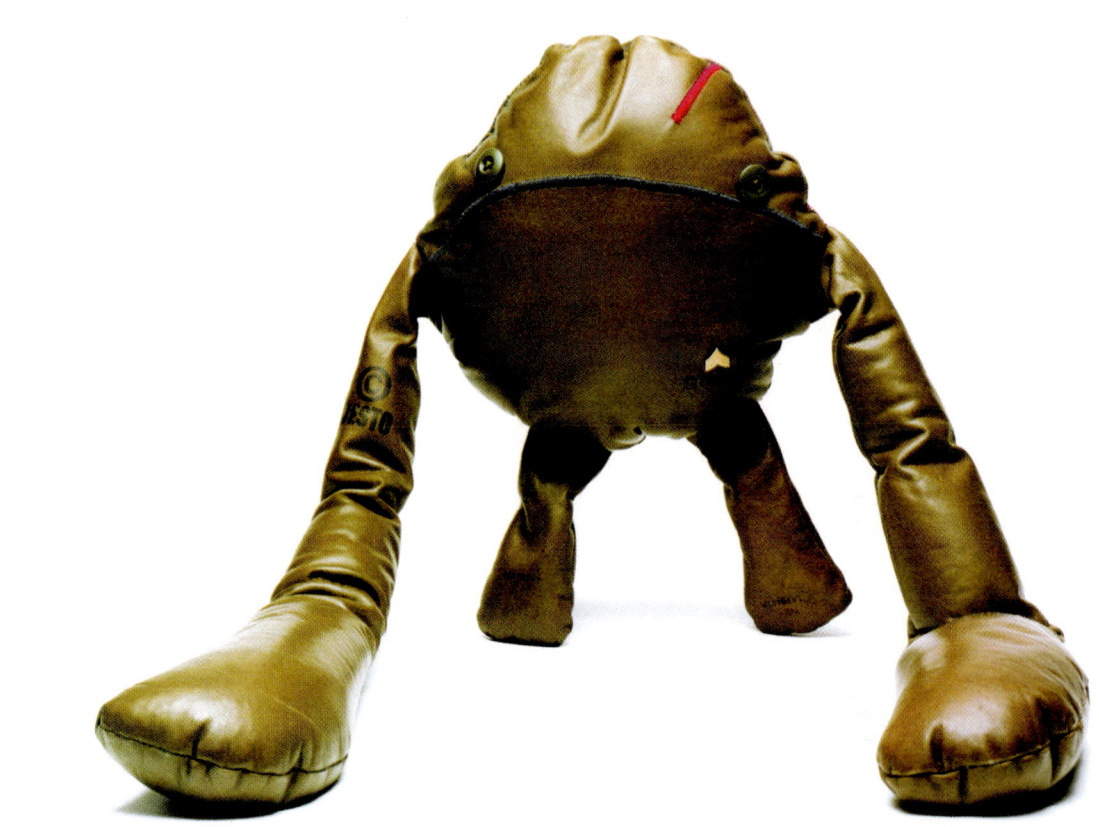

-2-

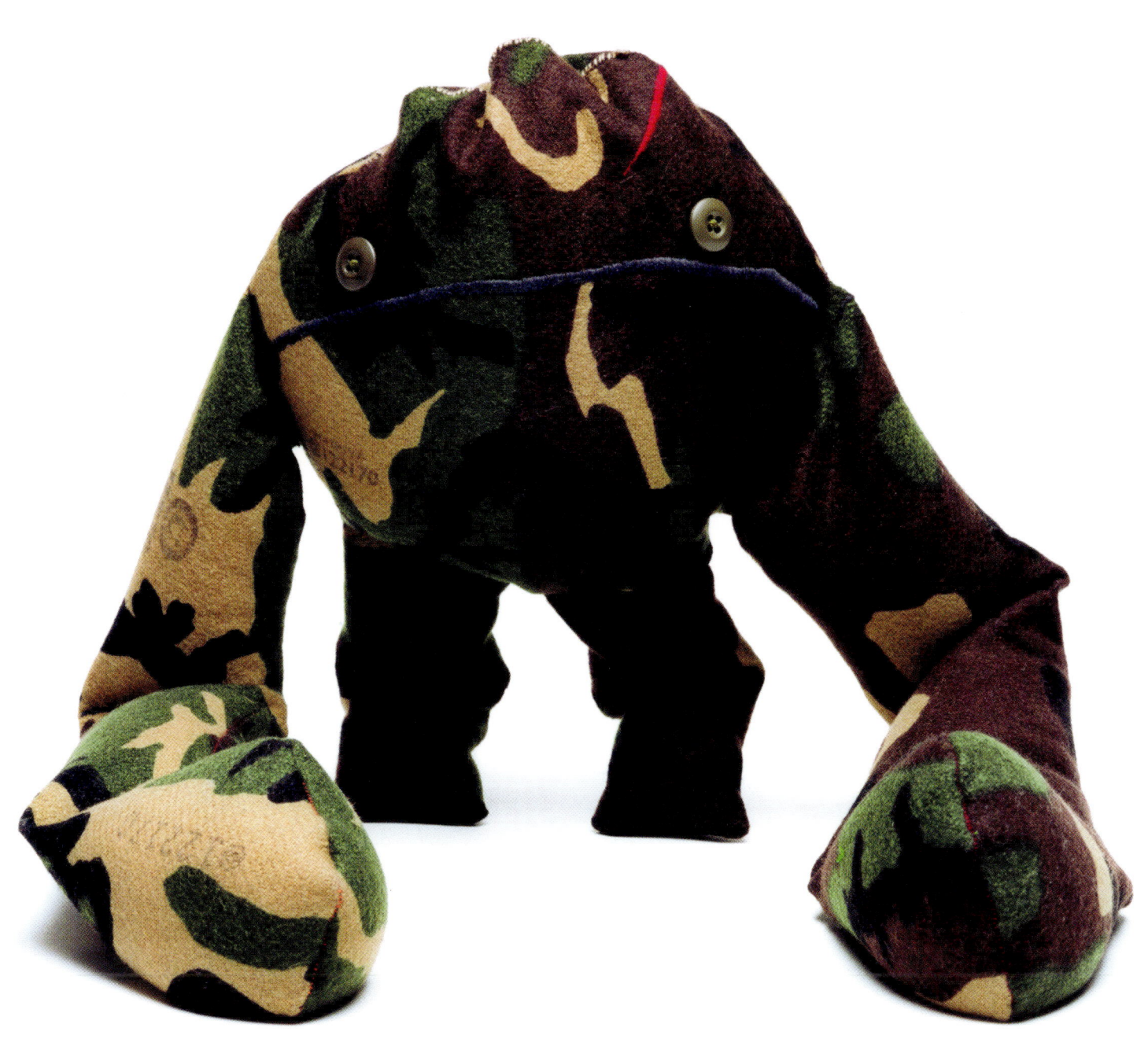

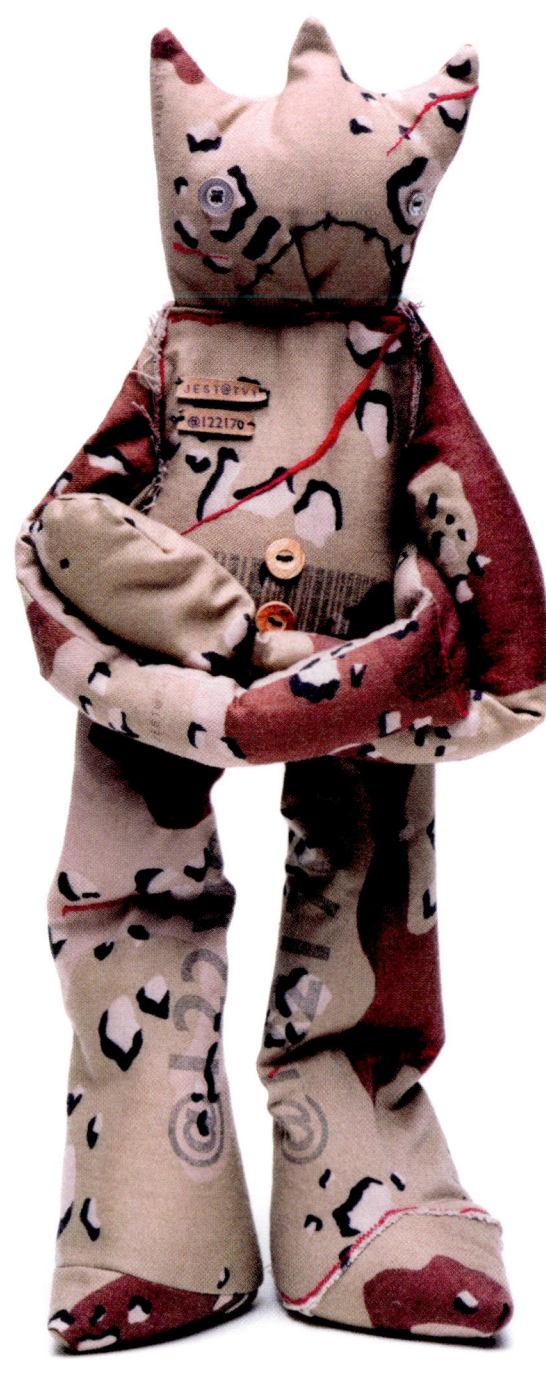

-1-

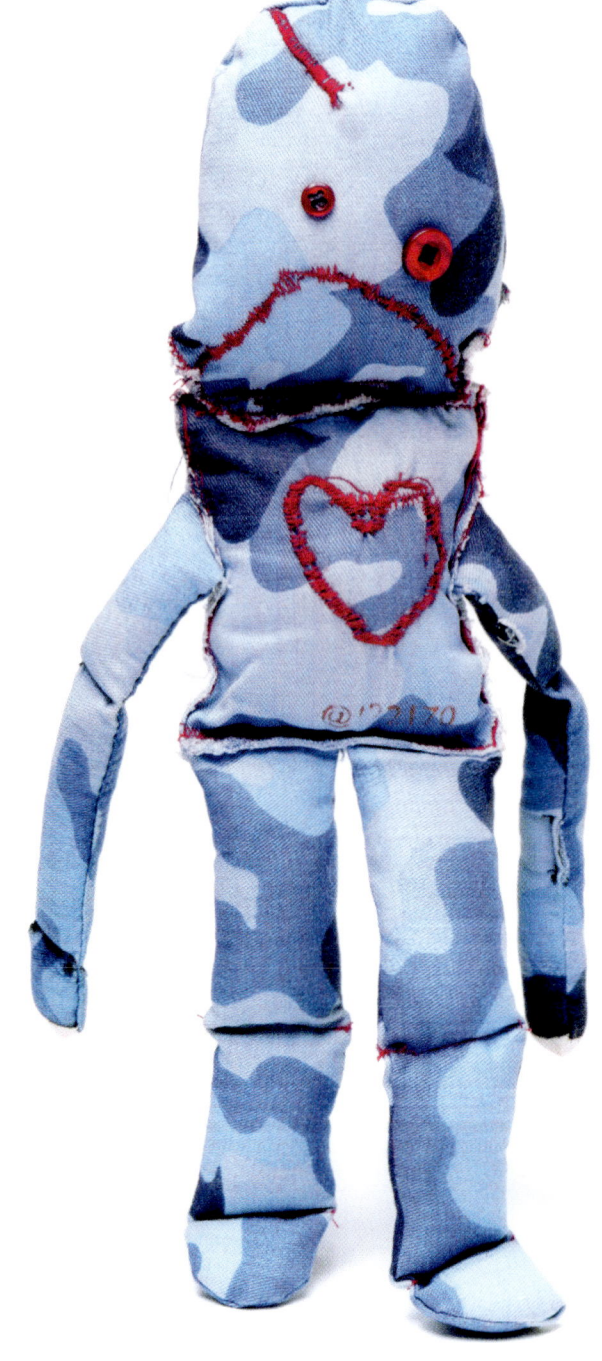

-2-

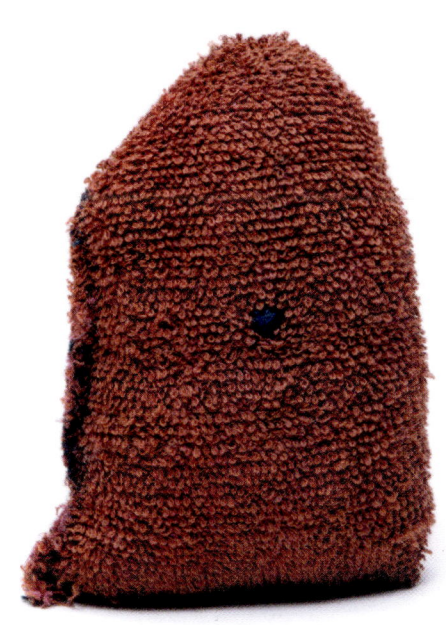

-1-

-2-

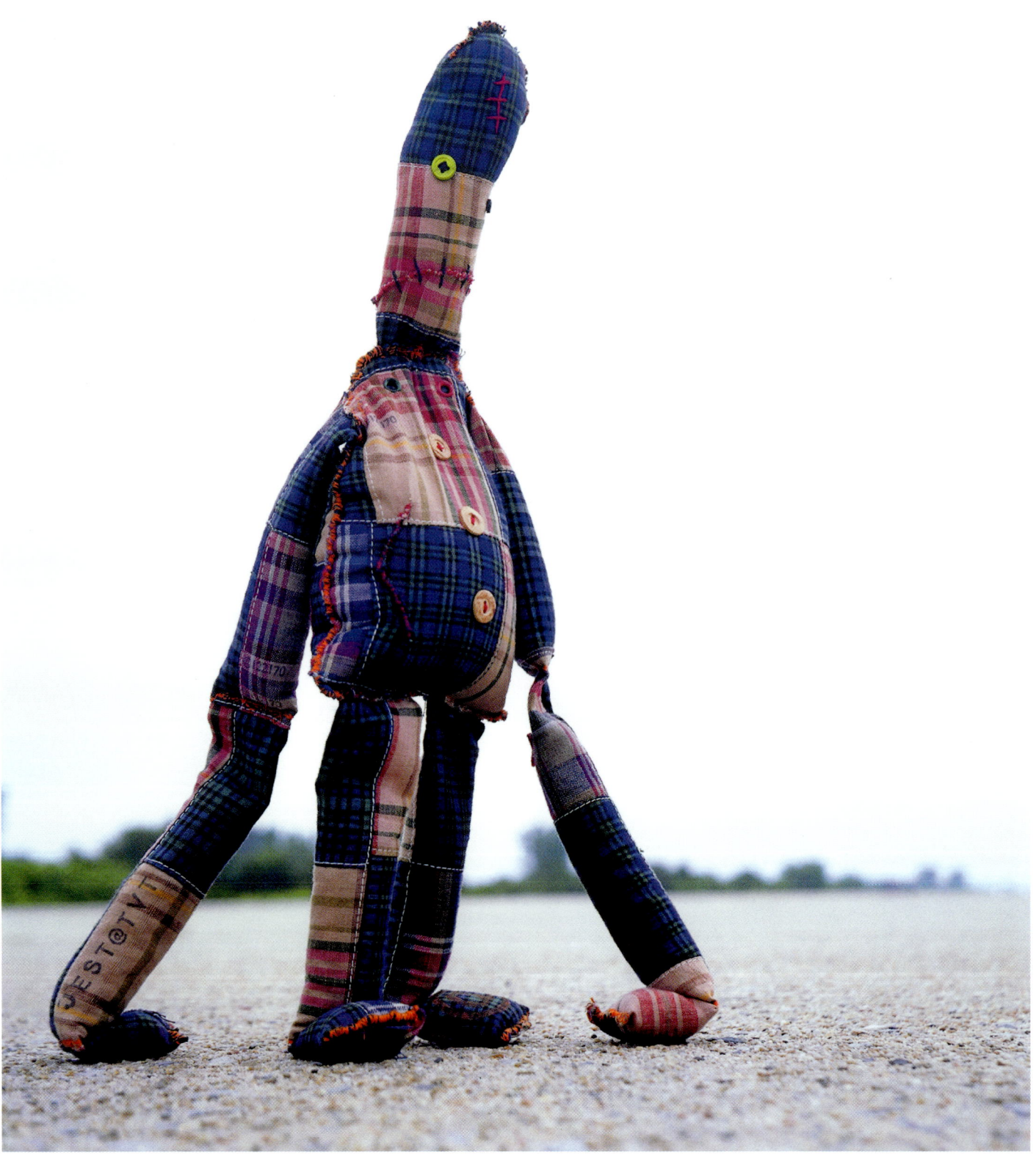

Ü / 37

-1-

-2-

U / 39

Ü / 40

Ü / 41

Ü / 43

Ü / 49

Ü / 51

Ü / 53

Ü / 56

Ü / 57

Ü / 61

Ü / 63

VIER5

PAGE No. TITEL

In 1999 Marco Fiedler and Achim Reichert founded the graphic design studio Vier5 in Frankfurt, Germany and recently relocated to Paris, France.

Very much inspired by fine art they not only devised a corporate design for the Manifesta4 exhibition but also stickers for Kunsthalle Tirol as well as a website for the Portikus Kunsthalle in Frankfurt.

Catalogues for artists such as Haegue Yang, Claudia Weber and Jens Risch as well as their corporate design for Eikes Grafischer Hort demonstrate Vier5s sensibility and understanding of the fine arts.

While Achim constantly develops type design, Marco has just rediscovered his infatuation with drawing. Their office lies right below that of Purple magazine. For presentations they wear white laboratory coats. Their dog is called "Torwart" (goalkeeper).

66-67	•	UNTITLED 25.07.02
68	•	UNTITLED 25.07.02
69	•	UNTITLED 25.07.02
70	•	UNTITLED 25.07.02
71	•	UNTITLED 25.07.02

MONGREL ASSOCIATES

The members of Mongrel studied at the Lahti Institute of Art and Berkshire School of Art and Design.

Mongrel was set up after stints at Taivas Hel (formally www.hel13.com) and Taivas Design, both of which are part of a larger advertising agency. After leaving these jobs and drifting into new ones Mongrel became very dissatisfied with the whole scene and decided to found their own company in August 2001. Mongrel's latest personal / commercial projects were for Dazed & Confused magazine while Junya Wanatabe at Comme des Garcons will produce 50 limited edition prints of Mongrel designs to be sold exclusively at Comme des Garçons in Tokyo.

"Within the arts and throughout history humans have been influenced by nature. And this is what shapes Scandinavian design."

PAGE No. TITEL

73-75 • WALLPAPER
STYLIST: ANNA KOMONEN
PHOTOGRAPHER: MATTI PYYKKÖ

BLESS

Desiree Heiss and Ines Kaag show the world of fashion in an unexpected light, with a humorous and somehow visionary touch. Since 1997 they have been collaborating as Bless to "present idealistic and artistic values in products to the public". Working between Berlin, Germany and Paris, France they experiment with various materials and different media not only to develop a new product range three times a year but also contribute to exhibitions and magazines around the globe. Since 2000 they have installed their temporary Bless Shops in places such as the former ffwd gallery in Berlin, Fanclub in Amsterdam or Kunsthalle in Basel. Right now they are just about to complete their BLESS N°.17 Design Relativators series.

The images shown were photographed and art directed by Bless for an introductory advertising campaign of the clothing line "HOLLY" by NOMINA INTERNATIONAL S.R.L. (Italy).

PAGE	No.	TITEL
76–81	•	ADVERTISING CAMPAGNE OF THE CLOTHING LINE "HOLLY" BY NOMINA INTERNATIONAL S.R.L. (ITALY).

KORATERS

PAGE	No.	TITEL

An avid drawer since the early days of childhood Shoko Nakazawa has kept a colourful and naive friendliness to her personal work. After studying at Joshibi University of Art and Design in Japan she worked on packaging, logos and character design. Since 2001 Shoko has been focusing mainly on characters and illustrations. With her portfolio website Koraters she has created a brimming universe of characters and storylines, with a little irony hidden behind the colours of the rainbow.

"Usually, when I start to draw I have no firm idea, and then the story just pops into my head and it turns out to be like this. I don't really know how this happens. What I picture in my head most of the time is a strange story of weird creatures and I just love them and try to make them cute. Previously, I used to draw them very colourful, but from this year on I have changed my style to use darker colours and I like it."

The result can be explored in the upcoming Koraters book.

82	•	KORAT VILLAGE
83	•	CONQUEST TEAM
84	•	KITTN
85	•	MOON LIGHT
86	•	HEBIKO
87	•	THERE ARE
88	1	FOPPISH
	2	KORATTA
	3	PIYOKKO
	4	HEBI KUN
89	1	SMALL TRAVEL 2
	2	MOGORO
	3	TAIL

Ü / 87

-1-

-2-

-3-

-4-

-1-

-2- -3-

BENJAMIN GÜDEL

PAGE No. TITEL

Illustrator Benjamin Güdel manages to tell an entire story in a single frame. Attending the same school as Martin Woodtli and Francois Chalet, Benjamin developed most of his drawing skills outside of school and through self-imposed training. While still in Berne he spent most of his time working on comics and illustrations and then moved on to Berlin and Zurich. Today he shares the K3000 office with a number of other designers creating images for the movie pages of Zurich's weekly paper Weltwoche. Some of those illustrations are based on film stills, others are his own interpretation of the plot. Most of the time he starts out drawing by hand and then finishes his pieces digitally.

90	•	CORINNE
91	•	SIBILLE
92-93	•	BROMMBEERCHEN
94-95	•	SEXY BEAST
96-97	•	BULLY
98	1	DSCHINGIS KAHN
	2	MEINE SCHWESTER MARIA
99	1	RESIDENT EVEL
	2	LAGAAN

Ü / 90

Ü / 91

PETER HORVATH

PAGE No. TITEL

Reminiscent of old fashioned collages and inspired by the likes of Russian constructivism, Dada and John Heartfield, most of the elements employed by Canadian artist and photographer Peter Horvath hail from the 20s and 50s. Exaggerating the stark, high-contrast depression- era as well as a glowing optimistic, Technicolor post war euphoria, Horvath's work remains eerily anonymous (not unlike a David Lynch movie), infecting his protagonists, terminally lost and confused.

Peter Horvath was born to Hungarian parents in Toronto, Canada. Camera in hand since age 6, he inhaled darkroom fumes until his late 20s and then attended the Emily Carr Institute of Art & Design in Vancouver. He immersed himself in digital technologies, co-founded 6168.org, a web-based site for net.art, and adopted techniques of photo montage which he uses to exhibit large-scale photo-based works. So far he has lived in Europe, the Caribbean, North America and some time in New York City. Exhibitions include Tokyo, Montreal, Toronto, and numerous net.art showings. He is a founding member of the anti web net.art collective Hell.com and likes to consider a future when high bandwidth will be free. His first book "Broken City" will be published in February 03.

PAGE	No.	TITEL
100	•	HIROSHI THE NUCLEAR SCIENTIST
101	•	THERE'S A CERTAIN PLASTIC SURGERY THING GOING ON
102-103	•	GUIDE TO UNDERWORLD DISCOVERY PRODUCED BY THE INDEPENDENT FILM CO-OP OF CANADA 1978
104	1	SCRATCHED OUT MEMORY OF MY AUNT
	2	M
	3	TURBINE/TURBO
	4	MANHATTAN SUMMER 2000
105	1	UNTITLED
	2	UNTITLED
	3	RED CITY, RED DESERT
	4	WHAT I REMEMBER ABOUT THE WAR
106-107	•	MEMORY BANK: RHODE ISLAND 1982 – SWIMMING WITH MY SISTER
108	1	AND TREPIDATION
	2	KRAKÓW POLAND 1939
	3	ERASURE
	4	TEXTURE CUTOUT PAINT BY NUMBERS IMAGE
109	1	FRANKENSTEIN RETURNS IN THE FORM OF SALIERI
	2	MY MOTHER, BLURRED
	3	FEET TOUCHING LIGHTLY PIANO KEYS (PART 2)
	4	FEET TOUCHING LIGHTLY PIANO KEYS
110-111	•	ANOTHER LANDSCAPE

Ü / 100

-1-

-2-

-3-

-4-

-1-

-2-

-3-

-4-

SEB JARNOT

Having spent most of his childhood drawing at school and his parents' bar in the village of Maine & Loire (France), Seb Jarnot naturally drifted into a graphic art school and gained experience at various agencies. Dismissed for being "headstrong" by an advertising agency where he had grown bored, Seb took up painting again.

In 1998 Seb got involved with magazines and music labels in Paris, as well as artists like Eric Morand and Laurent Garnier (F Communications) for whom he has been working every once in a while ever since. Amongst recent highlights in Seb's portfolio are his illustrations for an international Nike print campaign.

Seb's influences reach from Renoir to comic strips, from Picasso via German expressionism to contemporary fashion photography. He also claims to be heavily influenced by the lyrics of French singer/poet Serge Gainsbourg as well as David Bowie, Sonic Youth and Aphex Twin

PAGE	NO.	TITEL
112	•	UNTITLED
113	•	UNTITLED
114	•	SCI-FI SEX
115	•	PSYDOLL
116	1	UNTITLED
	2	UNTITLED
117	•	BRACROIZÉ
118	•	IT BEGAN IN AFRICA
119	•	UNTITLED
120	1	SHOES
	2	DVD LIVE L. GARNIER (F COMMUNICATIONS)
	3	L. GARNIER "THE MAN WITH THE RED FACE", EP (F COMMUNICATIONS)
121	1	PROMOCARD (STUDIO 002)
	2	MUSIQUES-ELECTRONIQUE
122–123	•	JUNE 2002 EXHIBITION-GALERIE PH. PANNETIER-NÎMES (FRANCE)

Ü / 113

SCI FI SEX

Ü/114

30 7 02

Ü / 115

Ü / 117

IT BEGAN IN AFRIKA

Ü / 119

SHOES

Laurent Garnier
Unreasonable live

The man with the red face
Laurent Garnier

-1-

✴ normal ✴ full screen
MUSIQUES-ELECTRONIQUES.COM

-2-

Ü / 121

Ü / 123

NEASDEN CONTROL CENTRE

PAGE　No.　TITEL

Neasden Control Centre is a collective formed in 2000 as a visual agency by Smith and Diamond as "another space from which to shout". Matt Ward and Ross Holden joined soon after – together they work in all forms of visual communication: from group exhibitions and limited editions to design for the music industry.

Neasden Control Centre has worked, illustrated and designed for ad agencies, art galleries, bars, book publishers, charities, clubs, conferences, design agencies, magazines, musicians, the music industry and themselves. In addition to this the studio collaborates with companies and individuals on a number of outside projects and commissions worldwide.

Among others their work has been published in Ape Magazine, Arkitip Editions, Beast Magazine and The Big Issue. Some of their most recent clients were MTV and DSL55.

The last record they bought was "Swiss Mountain Tunes / Am Lauberhorn das isch enorm" by Trio Eugster (Altana Records 1978).

124-125	•	UNTITLED
126-127	•	UNTITLED
128-129	•	UNTITLED
130-131	•	UNTITLED

Ü / 124

Ü / 125

WE ASKED **DR JACOB VON NELSO**

Report 0001 (Pound Shops)

If the World was a Pound would I??

Spend it ??
Flip it ??
Bet it ??
Fly it ??

We asked Dr Jakob Van Nelson, a trailing scientist taking a break from his egg-plane project in Devon. What is beneath, under over around and on top of the pound shop if anything??

Here is the following report:

Dr Jakob: You could write everything I know about pound shops on the back of a pound and so I did. Here's what it read like before I spent it paying for the dry cleaning bill to get the humour out of my suit. No ounces on me my good man. I'm clearly sound as a pound. The noise?? Well a little yellowish brown suede.

Carry on. If I had a pound for every time I heard that line I could have bought my very own pound shop. Fighting against the 99 ice-cream van man who I think is winning the trading war, I suspect it's very much like a race against time for tea or it's literal Russian Roulette. Load the gun with just one pound; roll the barrel and aim. I shoot into the green eyed, green lit, dusty ravaged assembly lined one stop coinvile. Checking my results I wondered if indeed I did get unlucky and hit the 8 pack of Soap powder? Or did I get real lucky and fire the 90 pack of crisps? Or horror of horros did I kill the two Gnomes for one?

1

BARNET

"Quac"

Report 0001 (Pound Shops)

paint telephone on nails

WATCH

54 WITH IT GROOVY

SAND BEE

HONG KONG CHINA

HE

Julie

MALE WEST ONE
WHAT DO THE CHICK'S DIG

Coin-Operated. That's what it was. Not a duck. Quack once for left, twice for right, three times a shady.

Some times now I believe it has become customary common place to see a lady of the night trading places unbeknownst to the other evaders of the realm and just wanting to have a good time. Not satisfied by the protection of the lobster law of the street they look to these "safe bet" shops. £1=1 win. Lets see how some men get their filthy rich kickers. The following names haven't been changed to protect you from the sun.

Scott Shoe. 50/1.

Well I normally come in here and spend £3 and get to bunch pegs on my itcy bits. Or I could be here all afternoon and get the lot for a giraffe [£75] soap, bin liners, coat-hangers, nodding dog's all in a c*m frenzied fashion. Here's some alternative names for the pound;

A Golden Crower
A Solid Victor
A Slipped Discus Thrower
A Yellow Boy
A Toothtaker
An Edwardian Monk's Toe
A Piss Chipper

Which would you rather I wonder? Disturbing stuff indeed. How about from the other side of the till then?

2

"Chic"

Report 0001 (Pound Shops)

Julie Aluminim. 17.

Julie still plies her trade from the Brighton Branch. She tells us she was here when all you could see were 50 pence pieces. Learning under the old system addicts her the hard way.

You get some people who think it's a game of chance. Of randomness like the universe. It's bit like that dog they tried to land on. Y'know the moon dog. Like Plato but with UV lighting. Thay all come in here like some Las Vegas Chink Chink Cowboy who's all cash flash dash (infamous 1980's leisure wear) with twinkle toes and a huge greased mamba. Christ I've seen em all.

Will I get out alive alive oh I wonder? The shop floor is a labyrinth. A bomb site. It's certainly one of those places where everyone just drops everything on the floor. There are actually more goods on the floor than on the wobbly shelves. Everyone in here has it seems like has a purpose, a goal. It's like they're on a mission from the cheap God. A kind of GODS OWN brand if you will. Boy that would swell.

Why does he want you to buy that egg timer if you've already own one?? It's only a pound, they answer in CD of joy unison looking to the sky to get approval from the great big bird like man encircling.

And with that I leave. Flat out on my one wheeled omni-chopper.

*All work supplied and copyright "Do Jacob and the Amoeba Tents [planted twice, once removed].

3

NIKO STUMPO

Niko Stumpo is the "abnormal behavior child". He moved from studying painting and sculpture at the Fine Art School of Roma to being a pro skateboarder and a gifted designer. The 26 years old is now living and working in Milan.

Niko uses his own drawings, paintings and illustrations as well as pictures from his movies as the basis for collages which are arranged on the screen and then either printed on paper and t-shirts or published on the web. Color is very important in his work.

His style has been appriciated by clients such as MTV Italy, BMW or Nike and he was also rewarded for his work at numerous conferences and competitions. Always busy he is working on several projects at the same time one of which is his first book project.

Niko's personal experimental project is called ABC :
(http://www.abnormalbehaviorchild.com)

PAGE	No.	TITEL
132	•	UNTITLED
133	•	UNTITLED
134	•	UNTITLED
135	•	UNTITLED
136	•	UNTITLED
137	•	UNTITLED
138	•	UNTITLED

BASTIEN AUBRY

PAGE No.	TITEL
138-143 •	IMBISS

Arriving in Berlin in 1995 Bastien spoke little German and played himself a home-recorded audio tape version of the movie "Taxi Driver" on his walkman to learn the language. Leaving the city after two years later he wanted to take a souvenir and started to photograph the small fast food stalls typical for Berlin. With an almost ethnological approach he captured the architectural style as well as the variety of signs, lettering, colours and shapes of the recurring locations which had become an integral part of his daily life.

Bastien currently resides in Zurich, Switzerland. His professional work comprises graphic design and illustrations for clients such as German HipHop band Fettes Brot while he describes his personal projects as rough, simple, maybe naive drawings and woodcarving. He is also a founding member of Swiss art collective Silex.

Ü / 139

Ü / 143

INDEX

BASTIEN AUBRY

Bastien Aubry
Pfingstweidstrasse 31b
CH-8005 Zürich
Fon +41 (0)1 271 44 50
bastien@datacomm.ch

BENJAMIN GÜDEL

Benjamin Güdel
Schoeneggstraße 5
CH 8004 Zurich / Switzerland
www.guedel.biz

BLESS

Desiree Heiss and Ines Kaag
Berlin – Germany / Paris – France
www.bless-service.de
blessparis@wanadoo.fr
blessberlin@csi.com

BORIS HOPPEK

Boris Hoppek
Siegen – Germany
www.borishoppek.de
www.bimbos.tk

DEHARA

Yukinori Dehara
Tokyo – Japan
www.dehara.com

DIANA DART

Diana Dart
Berlin – Germany
www.littlemissluzifer.de

GENEVIEVE GAUCKLER

Genevieve Gauckler
17 avenue Trudaine
75009 Paris / France
Phone +33 (0)1 40 23 04 13
genevieve.gauckler@wanadoo.fr
www.genevievegauckler.com
http://www.pleix.net

PETER HORVATH

Peter Horvath
Toronto – Canada
www.6168.org

H55

Hanson Ho
Singapore
hanson55@singnet.com.sg

JEST

jest
New York City – USA

KEIKO MIYATA

Keiko Miyata
Yokohama – Japan
www.h3.dion.ne.jp/~k-miyata

KORATERS

Shoko Nakazawa / Koraters.
Tokyo – Japan
www1.ttcn.ne.jp/~koraters
shoko@koraters.com

LORETTA LUX

Loretta Lux
Munich – Germany
info@lorettalux.de
www.lorettalux.de

MONGREL

Mongrel
Mermiehenkatu 28C (Basement)
00150 Helsinki / Finland
phone: +358 (0)50 529 4024 (english)
phone: +358 (0)50 3380608 (finnish)
info@mongrellassociates.com
www.mongrellassociates.com

NEASDEN CONTROL CENTRE

Neasden Control Centre
London – UK
www.neasdencontrolcentre.com
info@neasdencontrolcentre.com

NIKO STUMPO

Niko Stumpo
Milano – Italy
www.abnormalbehaviorchild.com
me@abnormalbehaviorchild.com

NONCONCEPTUAL

Nonconceptual
Nago Richardis + Dena Mooney
New York – USA
www.monikernon.com

PATRICK LINDSAY

Patrick Lindsay
5 rue Pascal
13007 Marseille / France
phone +33 (0)4 91.31.24.30
phone +33 (0)6 88.09.35.95
lindsay.patrick@wanadoo.fr
http://cycle.free.fr

RILLA

Rilla Alexander (Rinzen)
PO Box 944
Fortitude Valley
Queensland Australia 4006
www.sozi.com
www.rinzen.com
rilla@rinzen.com

PLASTILAND

Majken
Berlin – Germany
www.plastiland.de
majken@plastiland.de

PUPPETMASTAZ

PUPPETMASTAZ
Berlin – Germany
www.puppetmastaz.de

SEB JARNOT

Seb Jarnot
Paris – France
www.sebjarnot.com
contact@sebjarnot.com

VIER5

Vier5
graphisme
Marco Fiedler, Achim Reichert
9, rue Pierre Dupont
F-75010 Paris
Phone : +33 (0)1 42 05 09 90
kontakt@Vier5.de
www.vier5.de

ÜBERSEE 02

will be released in January 2003

ISBN 3-931126-99-4